IMAGES
of America

DUANESBURG AND PRINCETOWN

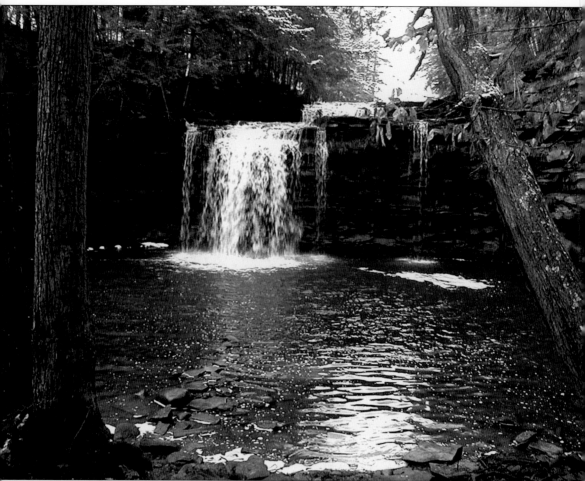

The upper falls on the Bozenkill Falls is located on the Christman Wildlife Sanctuary on Schoharie Turnpike. This sanctuary, developed in 1888 by farmer-poet W. W. Christman, was the first wildlife sanctuary in the United States. *Bozenkill* is a Dutch word that means noisy stream. The name was well chosen.

IMAGES
of America

DUANESBURG AND PRINCETOWN

Duanesburg Historical Society

ARCADIA

Copyright © 2005 by Duanesburg Historical Society
ISBN 0-7385-3803-5

First published 2005

Published by Arcadia Publishing,
Charleston SC, Chicago IL, Portsmouth NH, San Francisco CA

Printed in Great Britain

Library of Congress Catalog Card Number: 2005921531

For all general information, contact Arcadia Publishing:
Telephone 843-853-2070
Fax 843-853-0044
E-mail sales@arcadiapublishing.com
For customer service and orders:
Toll-free 1-888-313-2665

Visit us on the Internet at www.arcadiapublishing.com

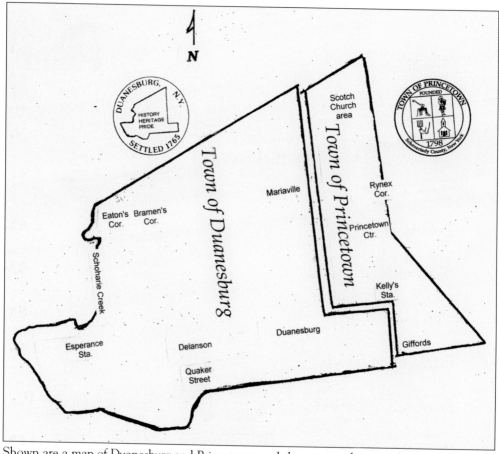

Shown are a map of Duanesburg and Princetown and the town seals.

CONTENTS

ACKNOWLEDGMENTS

The Duanesburg Historical Society expresses its gratitude to committee members Norman Collins, Bill Massoth, Pat Van Buren (editor in chief), Art Willis (Duanesburg town historian), and Irma Mastrean (Princetown town historian) for creating this visual history of the hill towns of Schenectady County. We would like to acknowledge the generosity of our communities in sharing their photographs and stories. We wish to thank our proofreaders Sally Burns, Eleanor Wages, and Judy Willis, who were essential to our accuracy.

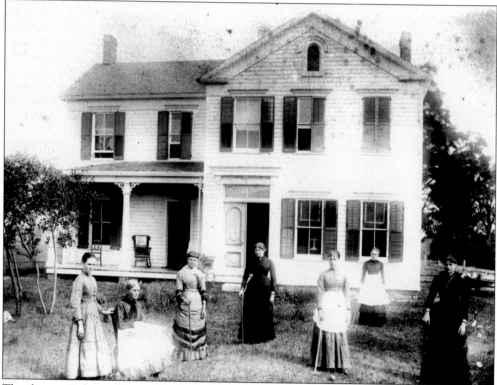

The former Robison House was located on Duanesburg Road in Princetown. Some of the women are preparing for a game of croquet. Pictured from left to right are Mrs. Kaley, Emma, Lucy, Mary and Louise Kaley, Laura and Nancy Robison.

INTRODUCTION

Duanesburg and Princetown, the westernmost hill towns of Schenectady County, rest directly upon Ordovician shale formed from clay and mud derived from the last surges of the Pleistocene ice age. The mighty Iro-Mohawk watershed once enveloped our region and now has been reduced to a shadow of its former self, the Mohawk River and Valley to our immediate north.

These two contiguous areas served as hunting grounds for Mohawk settlements along the Mohawk River and the Schoharie Creek. Duanesburg was erected as a township by patent March 13, 1765, and was soon joined with Schoharie under the title of the United District of Duanesburgh and Schoharie. Duanesburg was made a separate district March 24, 1772, and was recognized as a town March 22, 1788. Princetown was formed March 20, 1798, from a portion of the city of Schenectady, which had been ceded to the Reformed Dutch Church of that city and from lands originally patented to George Ingoldsby and Aaron Bradt in 1737. Schenectady County was formed by an act of the state legislature on March 7, 1809. Duanesburg and Princetown were included as its most westerly towns.

Duanesburg is bounded on the north by Montgomery County, on the east by the town of Princetown, on the south by Albany and Schoharie Counties, and on the west by Schoharie County and the Schoharie Creek. Princetown is bounded on the north by Montgomery County, on the east by the town of Rotterdam, on the south by Albany County, and on the west by the town of Duanesburg. Duanesburg is the largest of the five towns comprising Schenectady County. Originally known as Duanes's Bush and settled on 6,000 acres, Duanesburg now rests on 42,000 acres. Princetown is long and narrow; its greatest length from northwest to southwest is 10.5 miles; its greatest width is approximately 3.75 miles.

Both towns are well represented by wetlands and streams. Duanesburg contains the Schoharie Creek, Bozenkill Falls, Sheldon Falls, and Undine Falls. The Mohawk River, the Normanskill, the Sandsea Kil, and the Bonnybrook run through Princetown. The Upper Delanson Reservoir, the Peat Swamp draining into the Chuctanunda Creek, the Featherstonhaugh Lake Swamp (in the Featherstonhaugh State Park), and the Upper Normanskill Wetlands are noteworthy for the observation of wildlife and plant life. The Christman Sanctuary, off the Schoharie Turnpike, is well known as a natural landmark and as the historic home of W. W. Christman, winner of the John Burroughs Medal for Nature Poetry, and his son, Henry Christman, famous for his history of the Anti-Rent Wars, *Tin Horns and Calico*.

The namesake of Duanesburg was its chief proprietor, James Duane, a member of the first Provincial Congress that met in Philadelphia on September 5, 1774. Duane was a subscriber to the Declaration of Independence and a central figure in the formation of the New York Congress. James Duane was elected the first mayor of New York City and was eventually appointed federal district court judge. Duane had plans to make Duanesburg the capital of New York State, but the citizens of Albany had other and more compelling ideas. Princetown was named after John Prince of Schenectady, who was then a member of the Albany County Assembly.

While Princetown was mostly settled by immigrants from Scotland, such as the families of John Ferguson and Robert Liddle, it was well attended by the Bradshaws from England and the Rynex brothers from Germany. Duanesburg received its characteristic settlers from English Quaker stock, coming largely from the Four Corners in Duchess County in the 1780s. English Massachusetts Yankees, such as Thomas Freeman, arrived in 1736, along with Timothy Badgely in 1737, A. P. Crosby and William Crosby in 1738, Jonathan Brewster in 1770, and Palatine German families from Pennsylvania in the 1780s. In 1820, the population of Princetown was 1,023, and in 1790 the census figures in Duanesburg were listed at 1,650. With the exception

of those who settled in the valley silt lands just to the north and west of the towns of Duanesburg and Princetown, farmers had a difficult task due to the harsh and unpredictable climate in the hills, not to mention predation by wolves, bear, and other unsympathetic wildlife. In addition, many settlers were involved in long-term lease arrangements with the main proprietors of both towns, a one-way relationship wherein the tenant paid yearly in both labor and in kind. Particularly in Duanesburg, such feudal organization was deeply resented and led to the founding of an anti-rent association, the members of which pledged themselves to pay no rent and to resist any attempt to collect rents in conjunction with the Anti-Rent Wars throughout the Hudson Valley. Through most of their history, both towns were predominantly farming economies, but life was arduous and insecure on the land.

Within the scope of this introduction, it is impossible to detail the rich texture of cultural activity and significant institutions native to these hill towns. Nevertheless, it is imperative to list a few of their many distinctions. In Princetown, we note two churches: the Princetown Reformed Church and the Princetown Presbyterian Church; the former built in 1822, and the latter organized in 1770, under which the Princetown Academy, in close alliance with Union College, was established in 1853. We should mention Daniel Tulloch, great uncle of Marion McClaine, who served with General Sherman during the Civil War, was wounded several times and imprisoned by the Confederate Army, and was released and survived until 1883. On Maben Road, we behold the 1775 stone house built by Robert Liddle, who moved to Princetown, then called Corry's Bush, in 1741.

Because of Duanesburg's greater area and larger population, we find even more suggestions of cultural texture: in Eaton's Corners, Benjamin Cummings allegedly invented the first circular saw c. 1814; in Delanson, the largest coaling station in the world was constructed in 1907. These glimpses are only to mention a few of the plethora of historic sites and events in the towns of Duanesburg and Princetown. Delanson, Eaton's Corners, Quaker Street, and Mariaville alone have been designated as national historic districts, representing Federal, Greek Revival, Italianate, octagonal, Victorian, and salt-box architectural styles. In Duanesburg and Princetown, there are more than 40 national historic registry structures. Sites of mills, early factories, taverns, schools, hotels, stations, blacksmith shops, millineries, and many more establishments to meet town needs abound.

The town of Duanesburg is divided into five hamlets: Duanesburg Four Corners, where the North and Duane mansions can be found, along with Christ Episcopal Church; Quaker Street, home of the 1807 Quaker Street monthly meeting of the Religious Society of Friends, and Wolfe's Market, which housed the post office and many enterprises over the years; Delanson, a major stopping off point of the Delaware and Hudson Railroad, and site of Duanesburg Junior-Senior High School; Mariaville, centering around Mariaville Lake, and the hub of considerable economic differentiation during the 225-year history of Duanesburg; and Creekside (near or along the Schoharie Creek), on the extreme western portion of Duanesburg, delineated by four important, diminutive settlements: Braman's Corners, Eaton's Corners, Brooklyn, and Esperance Station.

As late as 1920, Princetown had five centers of population: Giffords in the south end contained a store, post office, the Princetown Reformed Church, and a hotel operated by J. Gifford; Kelly's Station consisted of a store and post office run by Andrew Kelly, a railroad station, and a cheese factory; Princetown Center contained the Princetown Presbyterian Church, and at one time, the Princetown Academy and Female Seminary; Rynex Corners was a thriving hamlet consisting of a store and post office, a hotel, a blacksmith shop, and a cheese factory; and Scotch Church at the north end of the town, so named because families attended the Florida United Presbyterian Church, or Scotch Church. While the collection of establishments and personalities are gone, these places as areas hold true today.

—Arthur Willis, Duanesburg Town Historian
—Irma Mastrean, Princetown Town Historian

One

DUANESBURG
FOUR CORNERS

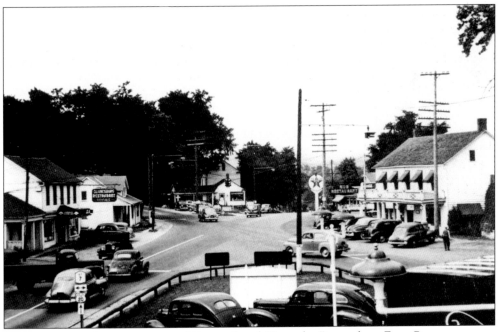

Looking west at the intersection of Routes 7 and 20, at the Duanesburg Four Corners, we can observe the hub of activity around the commercial establishments during the 1940s.

O'Neill's General Store, built c. 1826, was located at the western point between Route 7 and the Great Western Turnpike. Originally this building stood in front of what is now Check Marks Realty. The tall false front was removed in the early 1920s. It was jacked up, moved to Route 7, and placed behind the Check Marks building. Today situated next to the Duanesburg post office on Route 7, the building is now painted white and faces south.

The Case Hotel was a drover's stop and an inn for travelers on their way to Schenectady and Albany. A drover is a person who drives the farm animals to market. In later years, this establishment was known as the Hub Restaurant, a favorite dining place for travelers.

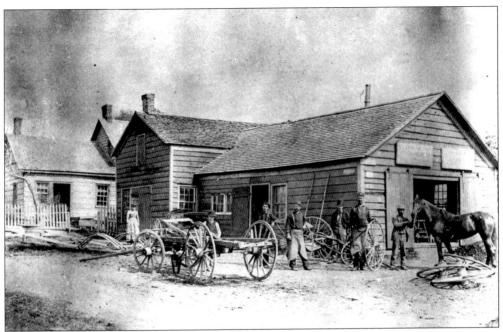

Harry Russell's blacksmith shop, located on the east point of the Duanesburg intersection, was the hub of the community. Besides shoeing horses, the blacksmith made and repaired farm tools, door hinges, and household utensils, among many other items. The young girl to the left is Ethel McDougall. The blacksmith's shop was torn down in the 1920s.

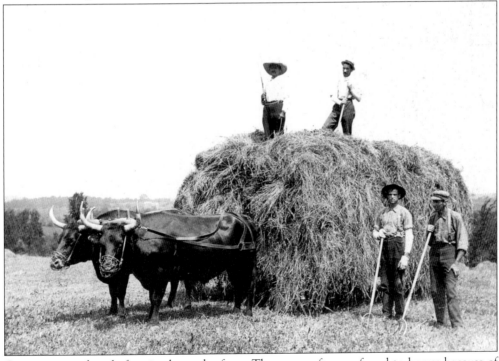

Oxen were used as draft animals on the farm. They were often preferred to horses because of their strength and their slow, even power.

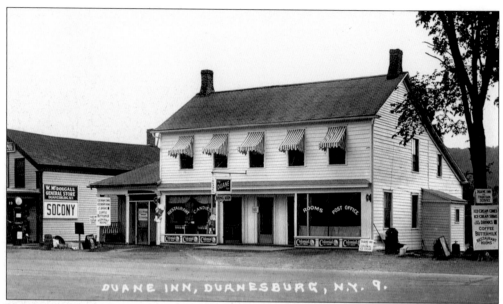

DUANE INN, DUANESBURG, N.Y. 9.

The Duane Inn was an early restaurant in Duanesburg. At one time it was called Dee's, and later, the Duanesburg Restaurant. Also, it was once the site of the post office. Now it is the medical office of Dr. Ze'ev W. Weitz.

William Schnetzler, a carpenter, stands in front of his home on Fiddler Road, off Weaver Road, c. 1908. This house dates to the early 1800s and is one of the oldest residences in Duanesburg. The original name of this road was Shetterly Road; in earlier times it was called the Bridle Path and continued on to the Duane Mansion. At one time there were two tanneries and three houses on this road. The Albert Fidler family now owns this home. (Note: The name of Fiddler Road was misspelled when it was originally renamed after the Fidler family around 1920.)

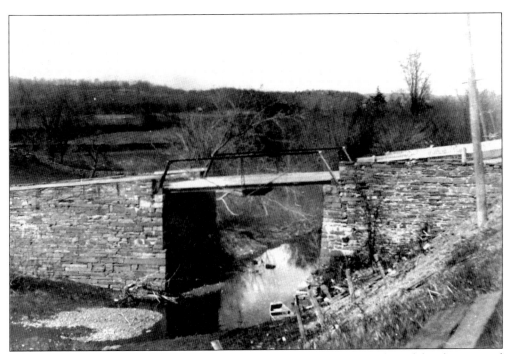

The early Great Western Turnpike was a heavily traveled toll road used by drovers and travelers. Gen. William North was the force behind developing the toll road. This bridge west of Duanesburg shows the condition of the roads at that time.

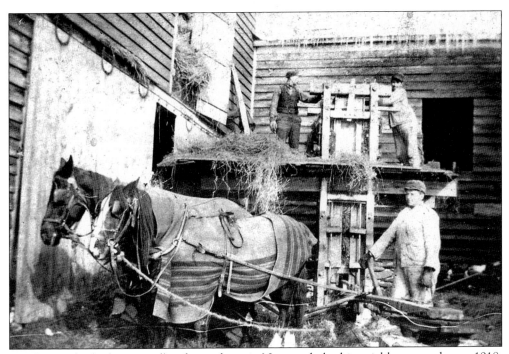

Lars Larson (right foreground), a farmer born in Norway, helps his neighbors press hay c. 1918. Larson's farm is on a town road that is now called Larson Lane.

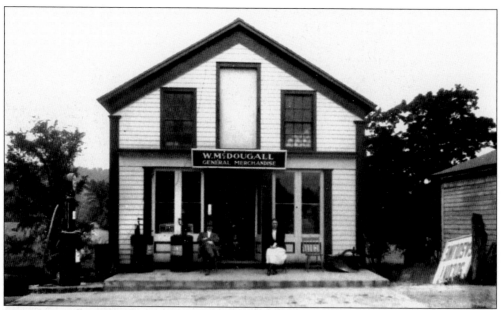

Wesley McDougall's store served residents as a grocery store. The Duanesburg Oil Company occupies this building today.

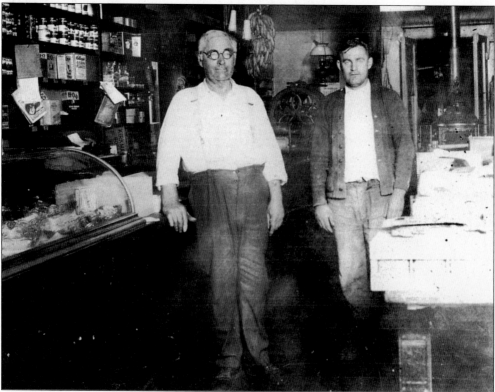

Wesley McDougall (left) and his son Ralph stand inside their store. It was typical of other stores of the early 20th century, when there was no self-service. A customer would wait while the proprietor retrieved and distributed the requested items.

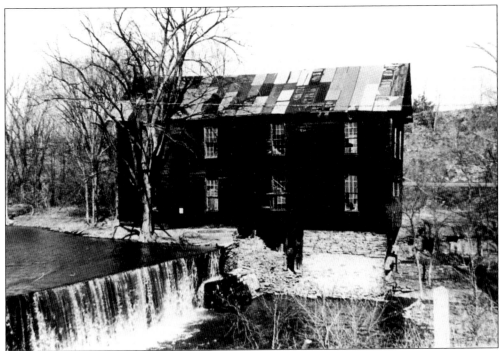

The Silas Van Patten mill was the second mill on this site. It was built in the late 1880s to grind rye, buckwheat, oats, and wheat into flour. The lumber to build the mill was sawn at an earlier mill on the pond.

James Duane built the first dam here in 1765, the same year that he founded the town of Duanesburg. This pond, formed by a dam on the Normanskill, provided waterpower for the first sawmills and gristmills in the area. At one time, ice was cut from the pond and sent by train to Boston, where ice was in short supply.

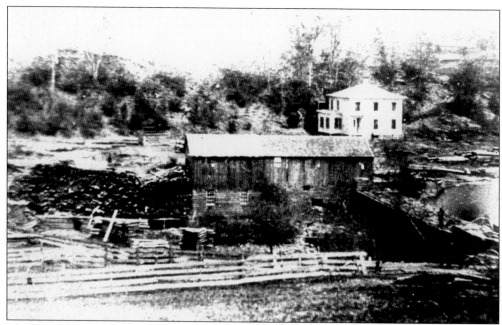

The Silas Van Patten home was built in 1897. The home and the property were purchased by the Delaware and Hudson Railroad in 1907. Part of the house was leased to the freight-express and ticket agent as a dwelling in 1908. The southwest corner of the building was reserved as a waiting room for southbound travelers. The Silas Van Patten mill is seen in the foreground.

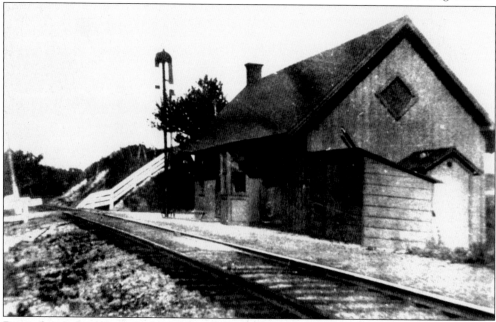

Duanesburg's first depot on the Schenectady and Duanesburg Railroad was built between 1870 and 1873 on the Great Western Turnpike, near where the present overhead bridge crosses. The railroad terminus was Delanson, where the Schenectady and Duanesburg line met the Albany and Susquehanna Railroad. The Schenectady and Duanesburg Railroad company merged with the Delaware and Hudson Railroad in August 1903.

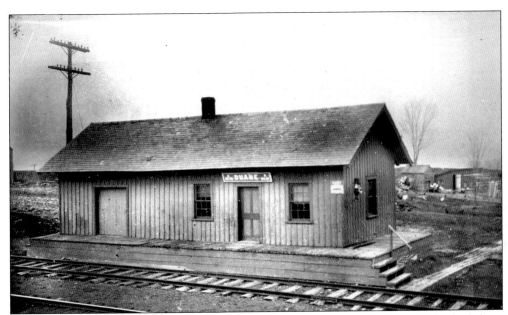

The Duane Railroad Station was built by the Albany and Susquehanna Railroad, which later became the Delaware and Hudson Railroad, and is currently the Canadian Pacific Railroad. The station was constructed in 1864 on the east side of the tracks, off of Route 7, east of Weaver Road. The first freight-express and ticket agent was John M. Bradt. The last agent was Roy Knowles, and the telegrapher was Nathan Fidler. The station was closed in the fall of 1928.

The stationmaster's house sat near Duane Station, on the east side of the tracks. Also built in 1864, it was no longer used by the stationmaster after 1928.

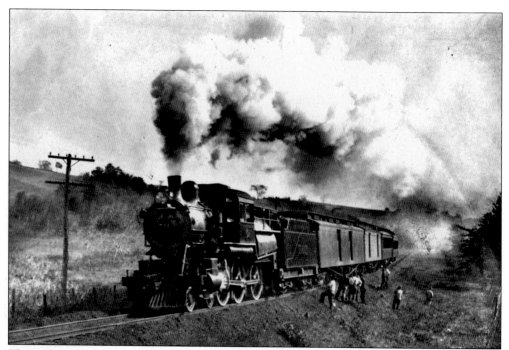

The early passenger train was pulled by a Mother Hubbard, or camelback engine. George Fidler took this *c.* 1910 photograph with his plate camera as the train was passing behind his farm off Weaver Road. Section workers can be seen in the foreground.

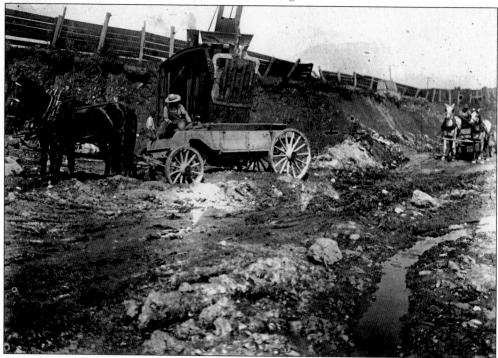

In this *c.* 1905 photograph, the wagon driver, Eddie Ryan, waits while gravel is removed from the gravel bank with a steam shovel at Duane Station.

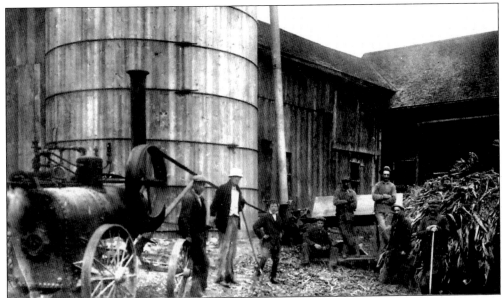

These men are workers on the George L. Fidler Farm off Weaver Road. Pictured from left to right are two unidentified men, Nathan Fidler, Myron Fidler (seated), unidentified, Herman Vrooman, George Fidler, Will Vrooman, and Ward Fidler (on the top of the load). The barns stood below the present-day farm of Albert Fidler. One of their barns was moved to the Howard McNitt property on Weaver Road.

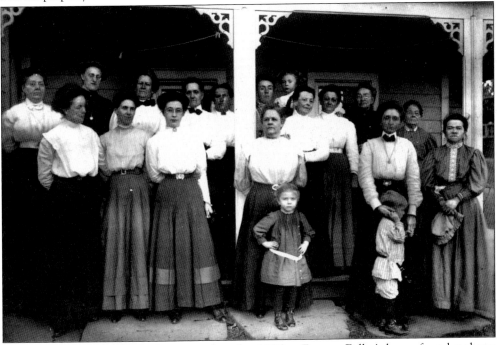

The Delanson Methodist Ladies are gathered c. 1905 at Frances Fidler's home for a luncheon of oyster stew. Frances Fidler is at the extreme right. Her mother-in-law, Sarah Fidler, is behind her. Standing next to Frances is her mother, Abagail White Liddle. The ladies took a morning train from Delanson to Duane Station and returned home on the afternoon train.

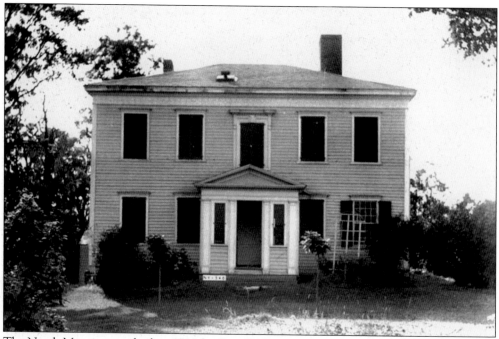

The North Mansion was built c. 1791 by Gen. William North in the American Federal style, a post-Georgian style known in England as Adam style. The North Mansion Road home is now occupied by Dave and Ann Vincent and family.

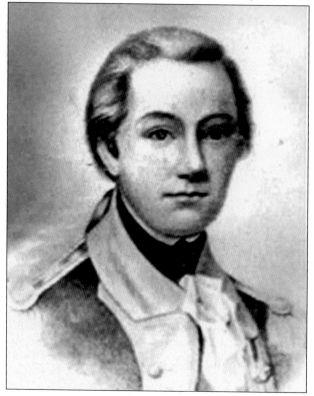

William North married Mary Duane, the eldest daughter of James Duane. North played a significant role as aide-de-camp to Baron Von Steuben during the American Revolution. After the war, he served as inspector general of the U.S. Army, county representative, and speaker of the New York assembly. He also was appointed U.S. senator by Gov. John Jay.

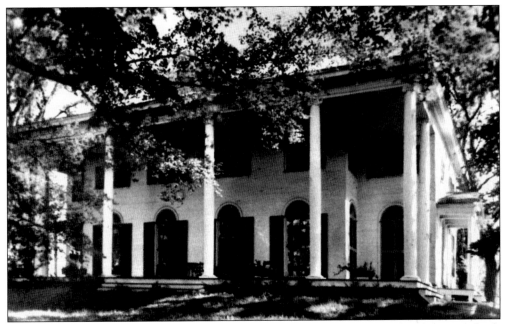

The Duane Mansion was designed by Philip Hooker, a famous architect of that day. It was built in 1812 for Catherine Duane, James Duane's unmarried daughter, at a cost of $11,000. In 1852, upon Catherine's death, the house was willed to nephew James Duane Featherstonhaugh. It is occupied today.

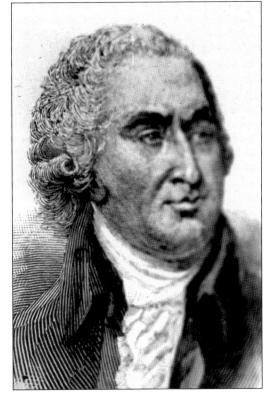

The town's namesake and chief proprietor, James Duane, played a major role in the American Revolution as a founding father of our republic. He was the first mayor of New York City, a federal district court judge, and a member of the First Provincial Congress. He helped found the New York State government and its constitution. Duane never lived in the town that he had founded; he died in 1797, as the early stages of building his mansion had begun.

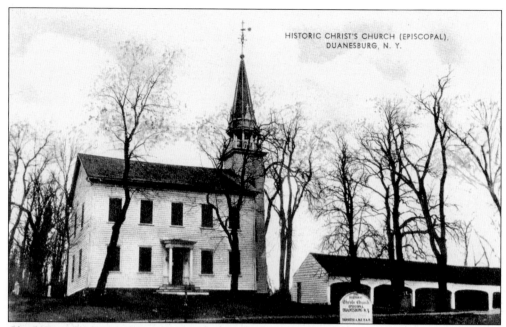

HISTORIC CHRIST'S CHURCH (EPISCOPAL),
DUANESBURG, N. Y.

Christ Episcopal Church, consecrated on August 24, 1793, was given by James Duane to the people of Duanesburg for the "public worship of Almighty God." Considered to be one of the town's most important historical sites, Christ Episcopal Church stands today in the quaint simplicity of its original structure.

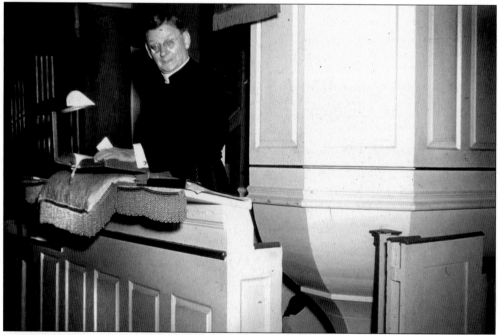

Rev. Edward Diamond, who served the Christ Episcopal Church from 1941 through 1949, is shown during his final service in August 1949. He returned to the church as an interim pastor from 1952 to 1954. Reverend Diamond was a founding member of the Duanesburg Historical Society and served as its first treasurer.

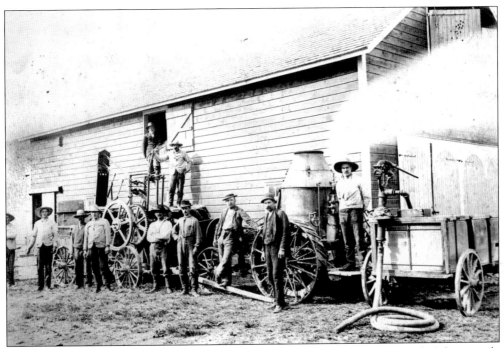

Representatives from the Westinghouse Farm Machinery Company of Schenectady demonstrate a vertical-boiler steam traction engine and a threshing machine at the Liddle Farm on Depot Road c. 1900.

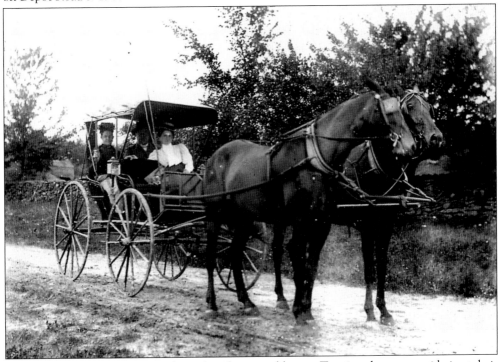

Duanesburg residents enjoy a ride in their horse and buggy. Touring the countryside in style is still a pleasurable pastime on a Sunday afternoon.

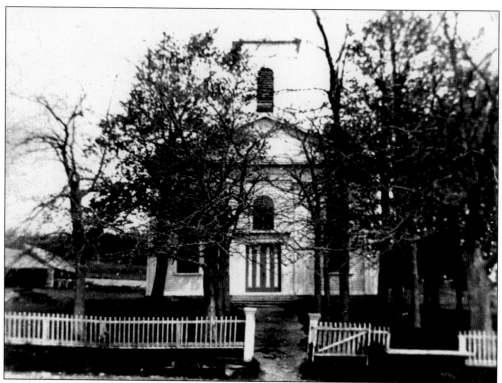

The Reformed Presbyterian church on Duanesburg Churches Road was built on land donated by James Duane. The congregation was organized in 1795. Pictured is the second church building. The first was constructed in 1807 and burned in 1836. This church was built in 1837 and burned in December 1951. The church's Sunday school, started in 1833 to teach English to the adult German immigrants, is the oldest continuing Sunday school in the country. The current Reformed Presbyterian church is located on Route 7 in Duanesburg.

Duanesburg District No. 6, the Lendrum School, was situated on the corner of the Great Western Turnpike and Schoharie Turnpike.

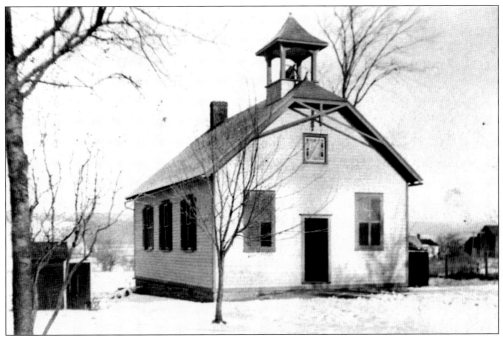

This Duanesburg District No. 5 one-room schoolhouse stood between Depot Road and Route 7 in the area of the present-day Reformed Presbyterian church's parking lot.

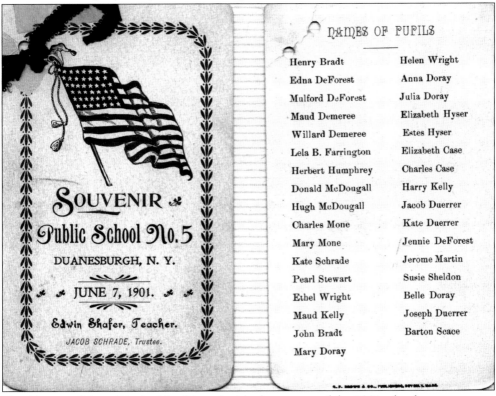

SOUVENIR

Public School No. 5

DUANESBURGH, N. Y.

JUNE 7, 1901.

Edwin Shafer, Teacher.

JACOB SCHRADE, Trustee.

NAMES OF PUPILS

Henry Bradt	Helen Wright
Edna DeForest	Anna Doray
Mulford DeForest	Julia Doray
Maud Demeree	Elizabeth Hyser
Willard Demeree	Estes Hyser
Lela B. Farrington	Elizabeth Case
Herbert Humphrey	Charles Case
Donald McDougall	Harry Kelly
Hugh McDougall	Jacob Duerrer
Charles Mone	Kate Duerrer
Mary Mone	Jennie DeForest
Kate Schrade	Jerome Martin
Pearl Stewart	Susie Sheldon
Ethel Wright	Belle Doray
Maud Kelly	Joseph Duerrer
John Bradt	Barton Scace
Mary Doray	

The "Souvenir" from District No. 5 is a cherished memento of the 1901 school year.

The new brick school building in the Duanesburg hamlet was built on the Great Western Turnpike *c.* 1925. It closed in June 1954, after the Duanesburg Central School District was formed, and the new elementary school was built at Route 7 and Chadwick Road. The Central National Bank opened a branch office here on October 28, 1963. It is now the NBT Bank.

The children of the Weaver School in District No. 19 pause to have a portrait taken with their teacher. From left to right are the following: (first row) Harold Vrooman and Irene Cass; (second row) Burton "Ted" Becker, Walter Murphy, Loretta Cass, Thelma Bell, Dorothy Bell, and Doris Larson; (third row) Ethel Vrooman, Gertrude Peters, Zemon Cass, Adam Cass, Norman Bell, unidentified, and teacher Miss Bays.

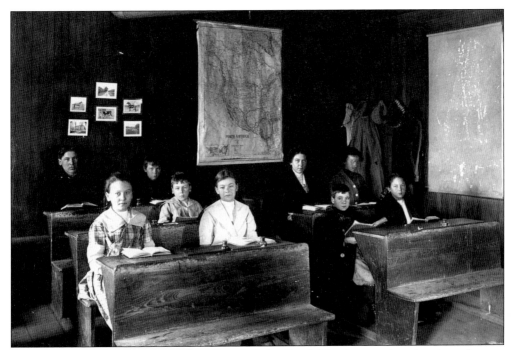

School District No. 11 was located on Scotch Ridge Road. This is a rare interior view of a one-room schoolhouse. Notice the well-worn desks and floor, the stovepipe (at top edge) extending the length of the room from the wood stove, and the darkness of the room.

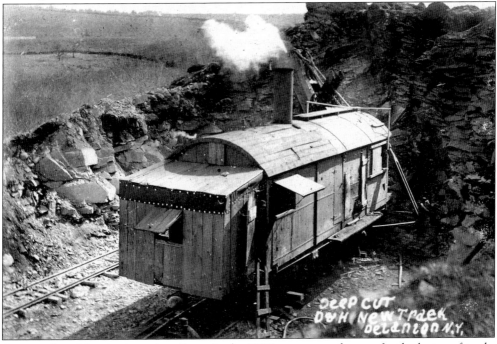

A steam shovel breaks through rock cut in the 1870s to prepare the way for the laying of tracks for the Schenectady and Duanesburg Railroad. This abandoned rail bed is now part of the Duanesburg Town Park on Depot Road.

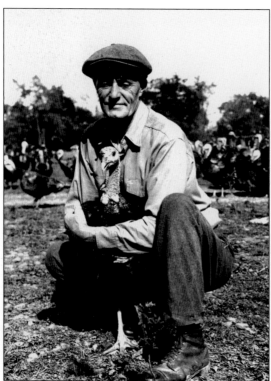

This 1949 photograph shows Mulford deForest on his turkey farm on North Mansion Road. He operated the farm from 1928 to 1960.

Murphy's Ice Cream Shop operated at this location on Route 20 from 1947 until 1955. The Quest End Craft Shop now occupies this building. Walt and Thelma Murphy eventually moved their shop west of Weaver Road to Route 7.

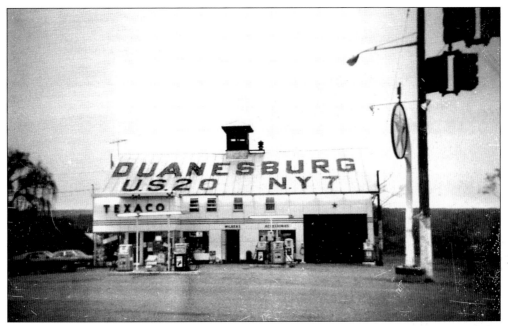

This building was originally a barn from the Case Hotel. Gid Wilber converted the structure into a garage and filling station in 1919, and then added a general store. The Texaco station at this location was purported to be the oldest Texaco station in New York State. Note the newly painted roof. Wilber was welcoming the first meeting of the Flying Farmers to Duanesburg.

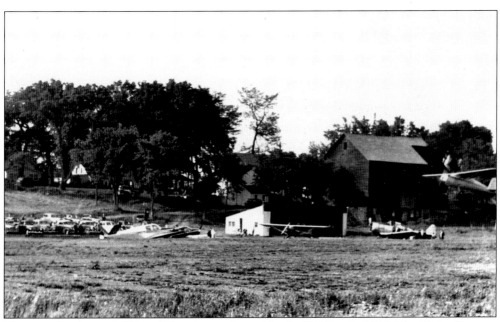

This social gathering of Flying Farmers was hosted by Gid Wilber in 1948. The Flying Farmers were a group of aviation-minded farmers who owned aircraft and had airstrips on their land. Wilber was also known as the "Flying News Boy" because he delivered the Sunday paper by airplane to his friends.

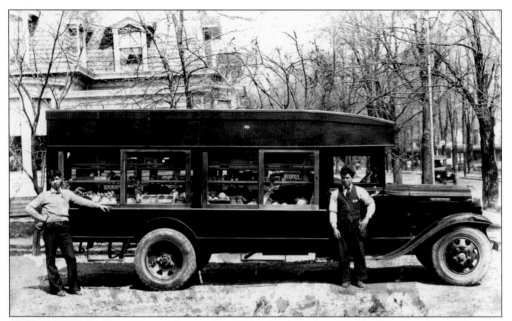

Philip and Mary DeLuke and their eight children grew fruits and vegetables on land along Depot Road. Phil DeLuke (b. 1896) sold his produce in bulk at Market Square in Schenectady. He peddled his fruits and vegetables throughout the town and as far away as Cobleskill. After a long day of making his rounds with his horse and wagon, DeLuke would often fall asleep, and the horse would deliver him home safely. Here we see his motorized grocery store *c.* 1940. DeLuke is on the right, and his brother-in-law, Nick Vittali, is on the left.

This view to the west shows the Duanesburg Four Corners, with Route 7 on the left and the Great Western Turnpike on the right. The first building on the left was the home of Wesley and Hettie McDougall. Next door was the residence of Hugh and Mary McDougall, followed by the home of Dr. Ralph A. and Kate McDougall.

Two

QUAKER STREET

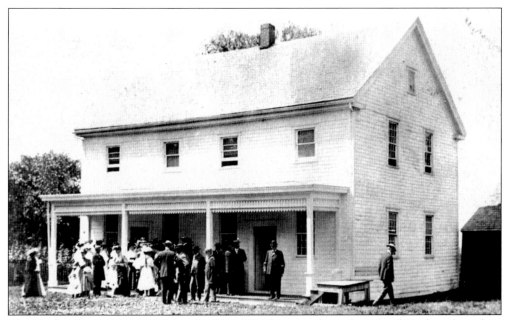

The Quaker Street Meeting House, built in 1807 by an early settlement of Quakers (members of the Religious Society of Friends), has been in continuous service since it was first opened. This meetinghouse replaced the original hand-hewn structure built in 1780 on the wedge of what is now Route 7 and Quaker Lane. In recent years, Quaker meetings are held here only during the warmer months due to cracks in the 18th-century wood stoves within. (It should be noted that Quaker Street is not a street; it is a hamlet in the township of Duanesburg.)

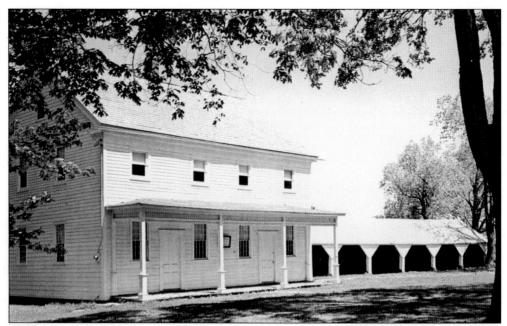

The long carriage shed that abuts the Quaker Street Meeting House was also built in 1807. Behind the meetinghouse is the Friends Burying Ground, which predates both structures. Previously used as shelter for horse and buggy, the shed is more apt to act as a place for storage and fund-raising activities today.

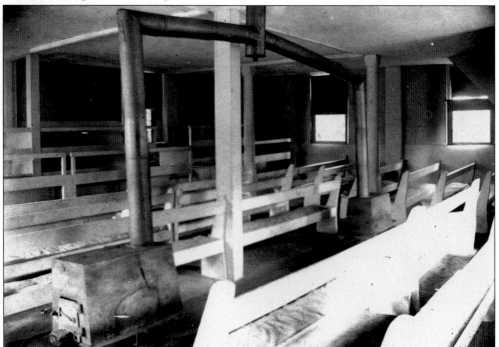

Painted gray and white, the interior of the Quaker Street Meeting House embodies the spirit of the Religious Society of Friends, which centers around simplicity and plainness. The strictly linear pews are unadorned and were only later padded. The windows are clear, untinted glass.

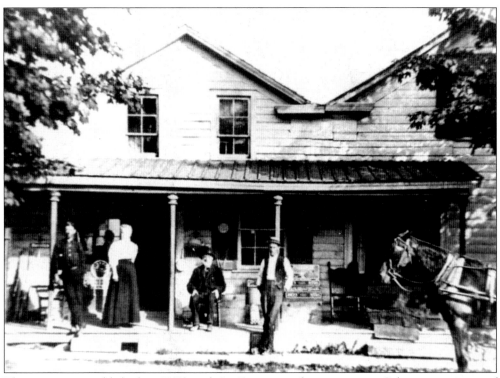

This store was established in 1875, with Ira Estes as its first proprietor. Subsequent owners of the business were Ira Hoag, H. C. Gaige, and years later, William A. Case.

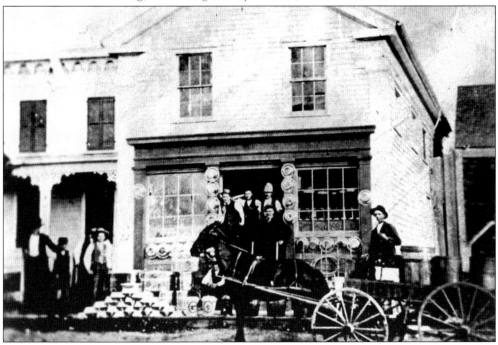

Melville Mead established a tinsmith and roofing business about 1880. He later expanded into a general trade in tinware, agricultural implements, stoves, furniture, and other hardware.

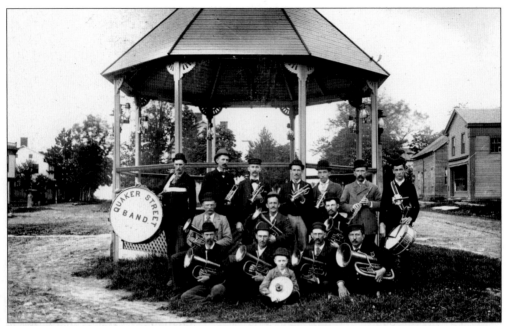

Quaker Street Band members gather by the gazebo. From left to right are the following: (first row) Frank B. Carpenter, Bert Sears, A. Calvin Witter Jr., Elisha D. Davenport, and David B. Crowe; (second row) Ozias R. Sheldon, W. H. Seward MacDonald, and Dr. Albert C. Witter; (third row) James Mosher, Isaac B. Gaige, Frank B. Hess, William M. Hoag (band leader), William Schnetzler, Edgar E. Tolles, and H. S. Beldon Crowe.

Originally constructed by Benjamin Estes in 1840, this house is an excellent example of Greek Revival architecture. Alonzo Macomber was the first to own the house, and he asked "Boss" Wright to do the finish carpentry and staircase. The above picture was taken July 4, 1919, and features Carrie Davenport and Emily Wilber. Emma Fleck is the current owner of this handsome home.

First erected next to Enock Hoag's farm, this crude frame building was moved in 1828 into Quaker Street Village, where it stood for several years on a lot adjoining the Nathanial Head property. After it was moved again several hundred feet southward across Schenectady Road (or Route 7), the structure was long used as a schoolhouse. The teacher there was Maria Peek, a maiden sister of Elder Peek, the onetime minister of the Christian Church.

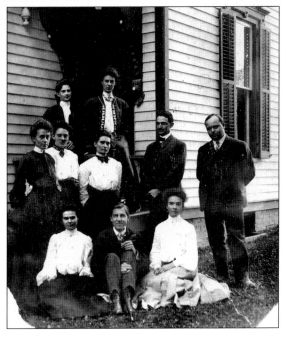

The Teacher's Institute was a 19th-century version of what today we call conferences for professional development. This weeklong institute was designed to assure a high scholastic standard. James Wingate (standing, second from right), superintendent of Schenectady County Schools, and F. W. Palmer (standing, far right) are pictured with several attendees. Some of the fine teachers in Quaker Street schools included Elisha Morse, Hattie Stevens, James Alverson, George Wilber, William Mellias, Frank Hess, John Bigsbee, Edith Gallup, Martha Wagoner, Grace Putnam, Florence Wilber, and Myra Mead.

The Pine Grove Farm on Quaker Street was a guesthouse that boasted a large shady lawn, wide veranda, large airy rooms with spring mattresses, a piano, croquet, daily mail, fresh eggs and vegetables, and free conveyance to and from the railroad station in Delanson.

The Independent Order of Odd Fellows, which at one time had its headquarters in the meetinghouse lodge room, later moved to Crowe's Hall, and finally to Delanson.

Rural Quaker Street saw signs of modern times when this early automobile and its proud owner appeared.

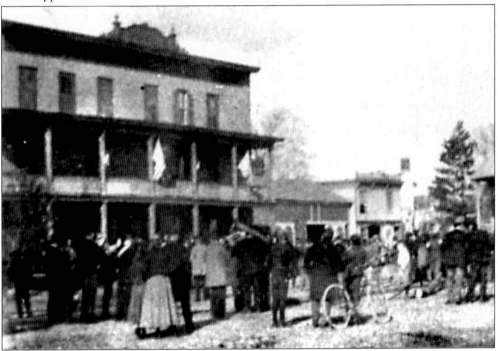

The American House was built by John J. Ladd and comprised 3 stories and 40 rooms for paying guests, plus living quarters for the manager. There were several barbers conducting their business as a service to the hotel, one of whom was David J. Putnam. The American endured two fires: one around 1875, after which the hotel was reconstructed; and another in 1911. It was not rebuilt thereafter.

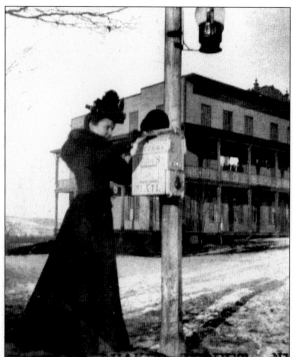

An unidentified woman posts a letter in front of Seward MacDonald's store. The American House can be seen in the distance. The hotel was located about where the Quaker Street Firehouse is now.

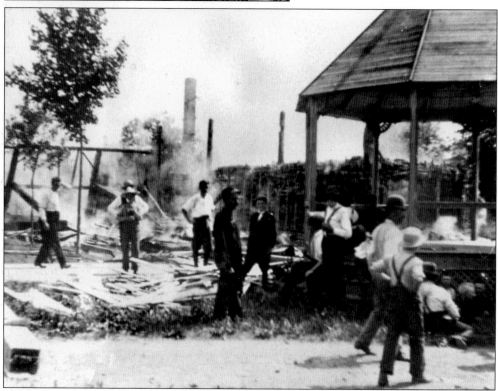

The aftermath of the fire that destroyed the American House in 1911 is viewed by the men and boys of Quaker Street.

David Crowe established the *Gazette and Leader* newspaper, and when this paper burned out in 1890, he started its replacement, the *Quaker Street Review*. The first newspaper in the Quaker Street area was founded by James Sheldon; it was named the *Star*.

This is a good view of the corner of Route 7 and the Schoharie Turnpike before the construction of the gazebo.

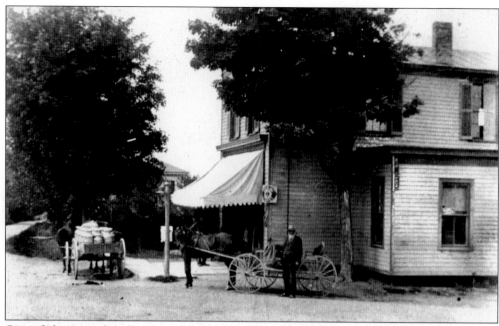

One of the central and most recognizable landmarks of Quaker Street is this 19th-century storefront. Constructed in 1883 between the Quaker Street Meeting House and the road to Delanson, the store has variously served as a boot and shoe factory, and a general store and post office. It has passed through ownership by DeWitt D. MacDonald and Seward MacDonald, Otto Heisig, Earl Cranson, and Dennis and Christine Wolfe, among others. This store has long served as the community gathering center.

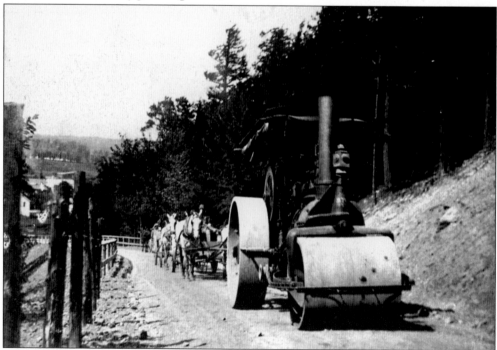

The hill between Delanson and Quaker Street was being rebuilt in the early 20th century.

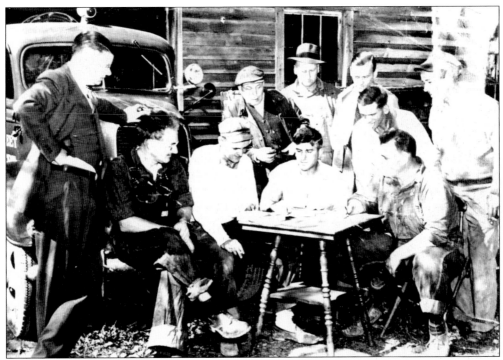

The Quaker Street Fire Department was formed in 1941. Making plans for the construction of their new firehouse to be built in 1949 are, from left to right, the following: (seated) Charlie Parker, George Hemstreet, Pat Coppolo Sr., and Fred Dykeman Sr.; (standing) Ed Bradley, John Rogers, Floyd Delap, Allen Hosier, Bob Hemstreet, and Lonnie Adams.

Remaining continuously within the ownership of Jonathan Soule's descendants, this farm dates from the mid-1780s. The barns were constructed in the English style in the 1840s, and were almost certainly community raised. This farm is currently owned by Arthur and Judith Willis.

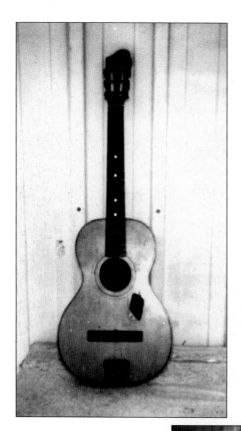

This Tonaharp guitar is one of two instruments manufactured by Edwin D. Wilber of Quaker Street. This seven-string guitar was played with a steel slider (like a pedal steel guitar) and had buttons to play the chords.

Inside the Tonaharp guitar, we can see the E. D. Wilber label. The other instrument he made was a 17-string Tonaharp, which was held in the lap and played flat. Wilber was a noted musician and vaudeville performer. He met his wife while they were performers on the Keith Proctor vaudeville circuit.

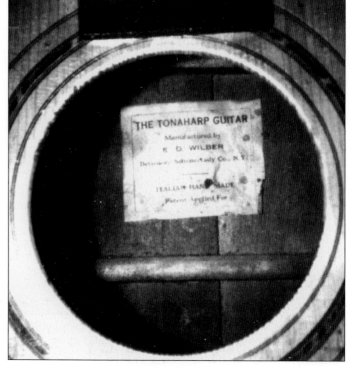

Ginger Rogers caused quite a local stir when she married a Quaker Street lad, John Calvin Briggs II, on January 16, 1943. The actress seemed to enjoy becoming acquainted with all of Briggs's relatives around the town when they visited to celebrate his grandparents' 60th wedding anniversary.

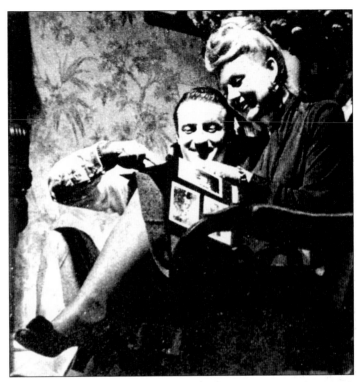

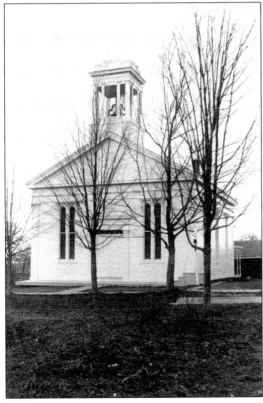

The Christian Church began as an outgrowth of services held in a chapel near Frink's farm, located south and west of the village proper. This church building was constructed in 1859 under the leadership of Rev. Henry Brown and B. B. Summerbell. The church has been in continuous service since it first opened.

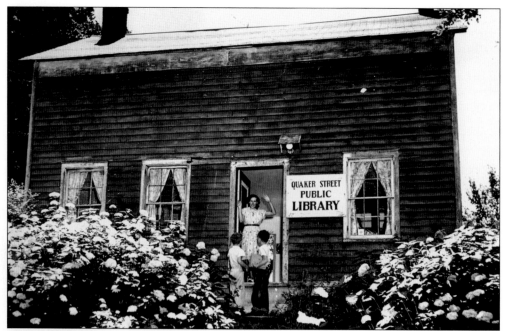

Nadine Sturges Crowe waves goodbye to Buddy Jones (left) and Roger Crowe (right) after they have made their selection of books at the Quaker Street Library. The library was started as a community project by the women of the Quaker Street Co-operative and later became a branch of the Schenectady County Library.

A scene on Memorial Day 1946 is pictured. Quaker Street and the surrounding villages within the town of Duanesburg have celebrated Memorial Day ever since its inception in 1865 following the Civil War. This is a view of the parade as it approaches the Darby Hill intersection on its way to the flagpole to present a wreath in memory of those who have served our country.

Three

DELANSON

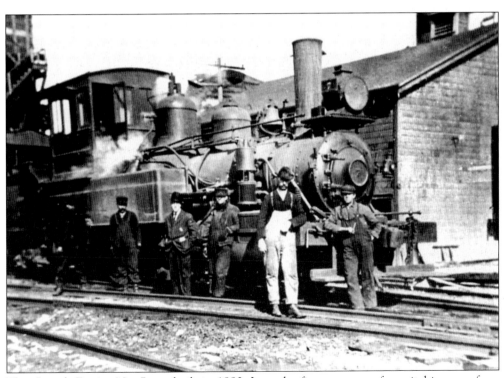

This Switch Engine No. 7 was built in 1880. It used a five-man crew for switching cars from one track to another at the coal facility. The man in the suit near the center of this *c.* 1910 photograph was apparently a railroad official.

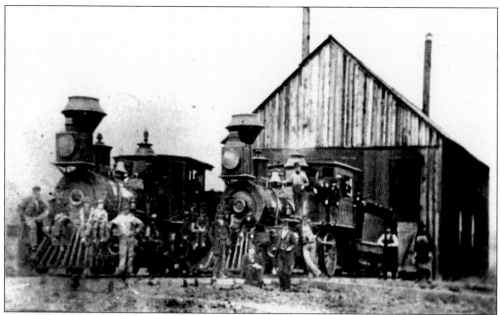

The Albany and Susquehanna Railroad was established in 1852, but for financial reasons, construction did not begin until 1858. The railroad arrived in Quaker Street Depot (Delanson) in the early summer of 1863. Built in 1868, this structure was the first locomotive shed in Quaker Street Depot. The building had a small turntable and housed two wood-burning locomotives.

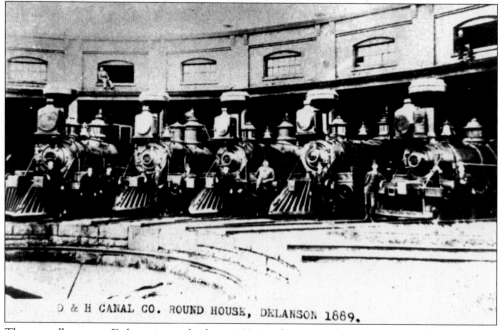

D & H CANAL CO. ROUND HOUSE, DELANSON 1889.

The roundhouse at Delanson was built in 1884 to house six locomotives. Among the men pictured is Lawrence Riley, the roundhouse foreman, who is shown with two engine wipers working on 12-hour shifts. There were five locomotives stationed at Quaker Street Depot: the 174 (the Bobby Burns), No. 176 (the David Downs), No. 177 (the D. M. Kendrick), No. 178 (the Moosic) and No. 75 (the R. G. Moulton).

46

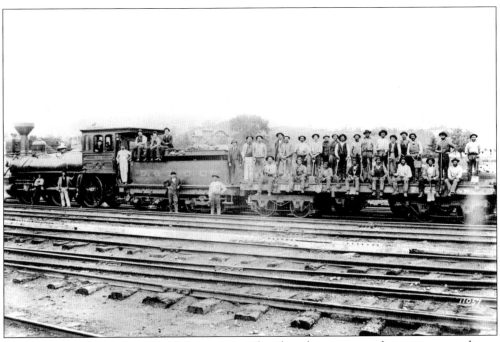

The Delaware and Hudson Canal Company's railroad work crew is seen being transported on a flatcar, setting out for a day's labor. Pulling the car was Engine No. 274.

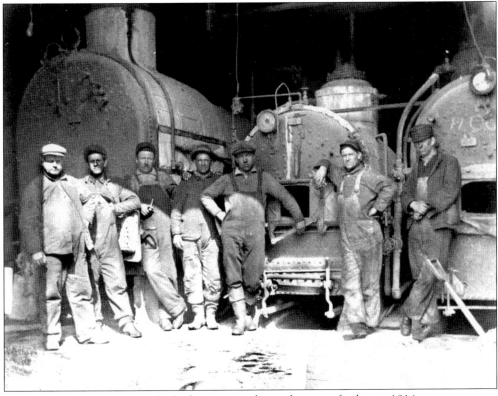

These men were workers in the boiler room at the coal storage facility in 1914.

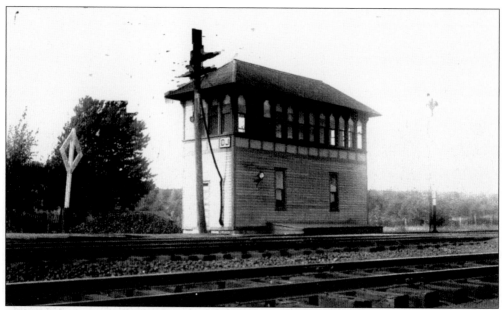

The DJ (Delanson Junction) Tower at Cole Road Crossing, which controls the yard switches and signals at the tower, was built early in the 20th century.

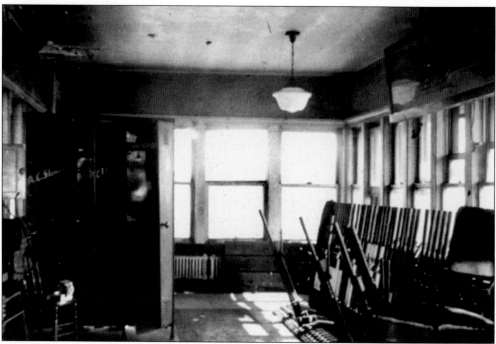

The interior view of the DJ Tower shows the long levers that operated the switches.

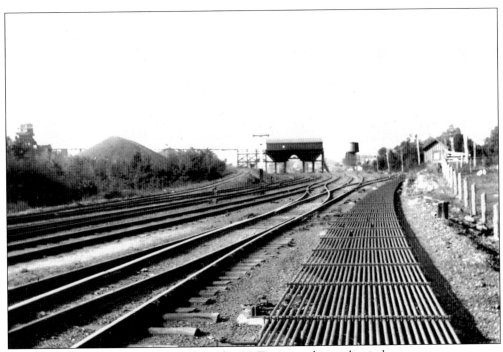

These are the switch rods that ran from the DJ Tower to the yard switches.

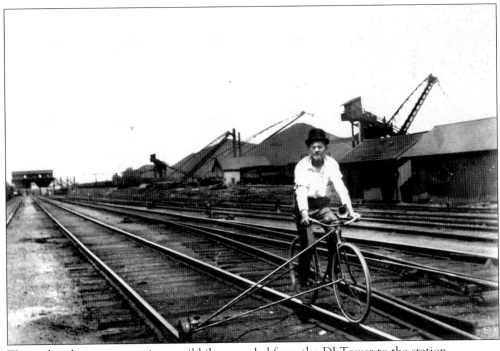

This railroad messenger, using a rail bike, traveled from the DJ Tower to the station.

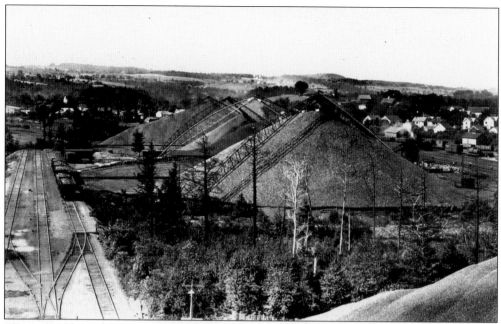

The coal storage facility was built in Delanson in 1903 under the supervision of James L. Cummings Sr. It was purported to be the largest coal storage station in the world. This view shows the rail unloading facility on the left and railroad mainlines on the right.

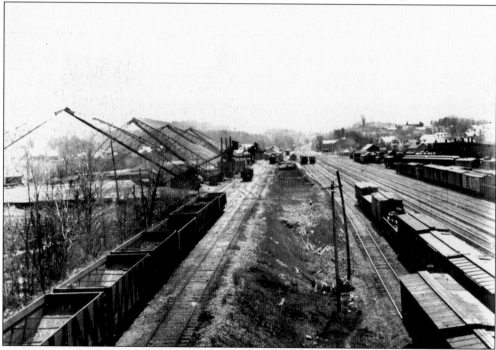

The Delanson yard was 14 tracks wide. Anthracite (hard) coal was stored on the south side and bituminous (soft) coal for locomotives was stored on the north side. Anthracite coal came in different sizes for various uses. The various sizes were, from coarsest to finest, as follows: furnace coal, stove coal, chestnut coal, pea coal, buckwheat coal, and rice coal.

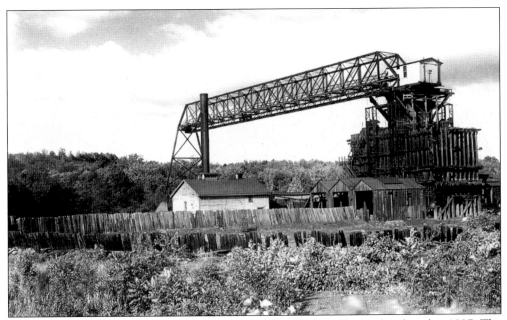

This is a 1939 photograph of the coal storage facility, which had been abandoned in 1927. The facility was demolished in the early 1940s.

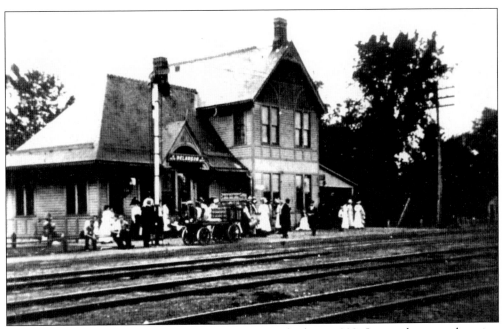

This combination freight and passenger station was built in 1882. It was the second station here. The first one was built on the south side of the tracks in 1864, one year after the railroad arrived in Quaker Street Depot. Some of the agent telegraphers who worked here were Arthur Wright, Otis Tulloch, Ray Smith, and the last one, Nan Patterson.

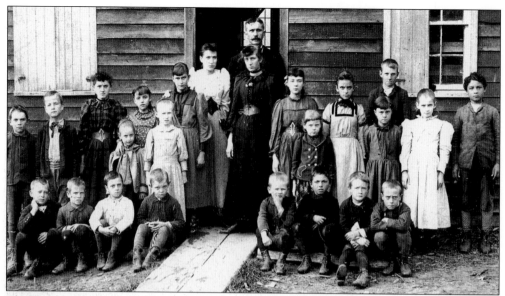

The Toad Hollow School (Duanesburg District No. 4) was an early school within the town of Duanesburg. John Delamater, the teacher, is pictured with his students c. 1885. The school had three different locations along Cole Road. This building was on Cole Road on land near the Normanskill. It is now owned by the railroad. As the population grew with the influx of railroad workers, a larger school was needed.

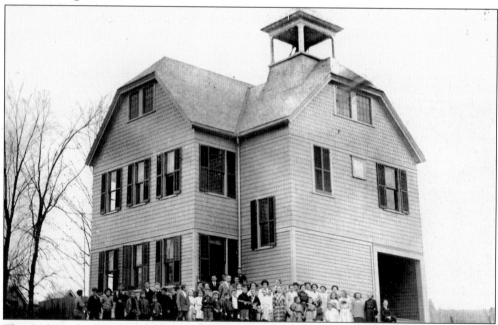

The settlement of Toad Hollow became Quaker Street Depot, but the school was still known as Duanesburg District No. 4. This two-room school was built in 1884 and accommodated four grades in the lower room with teacher Etta Shoudy, and four grades on the upper floor with the principal, Erwin B. Billings. Abandoned as a school in 1926, the building was sold first to the Gaige Publishing Company, then to Harold Ullman, who made it into a residence. Its last use was as the business office of the high school. The structure was demolished in October 2001.

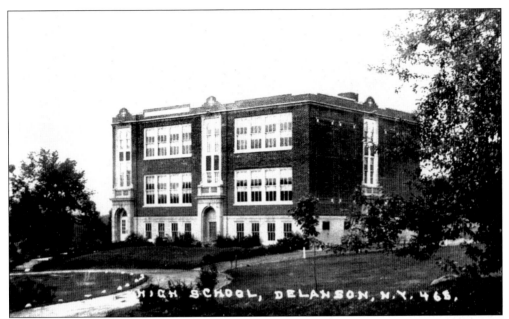

In 1892, Quaker Street Depot was renamed Delanson. As Delanson grew due to the activity of the railroad, the need for improved and larger schools became apparent. In 1923, District No. 4 united with District No. 3 (Quaker Street), District No. 9 (Thousand Acres), and District No. 19 (Weaver Road) to become Delanson Free School District No. 1. In 1926, the Delanson School was built to accommodate both elementary and high school students.

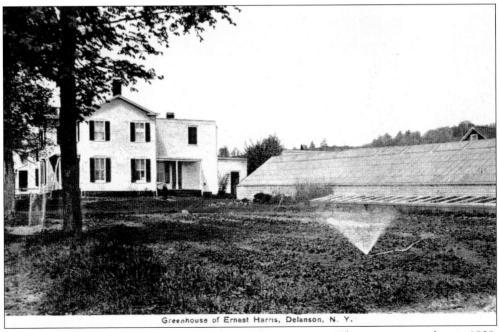

Greenhouse of Ernest Harris, Delanson, N. Y.

Ernest Harris operated a greenhouse in Delanson for many years. This picture was taken in 1908.

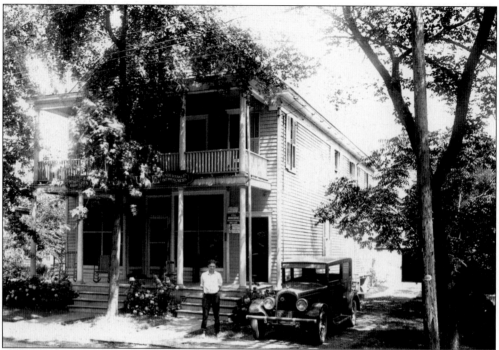

In this 1927 photograph, Galen White stands outside the White and Farquhar Funeral Home, which his father, Loren White, built in 1904. While being proprietor of the "Furniture and Undertakers and Embalmers" establishment, Loren White also was the postmaster in Delanson from 1893 to 1897, a justice of the peace in Duanesburg for 14 years, supervisor of the town of Duanesburg, a state assemblyman for two terms, and then a state senator for two terms.

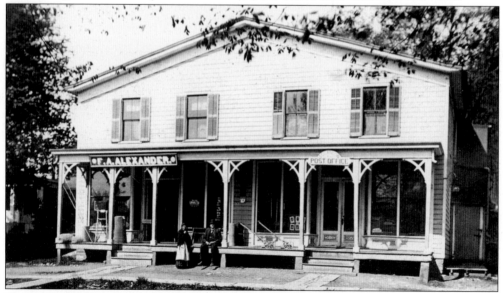

The Rector Building, located at the corner of Main Street and 1000 Acre Road, was built before 1880 and still stands today. The post office was established in this area in 1883 and remained for about 100 years. Fred Alexander's store did business here (on the left) in the early days, and there was a hall upstairs for public and fraternal gatherings.

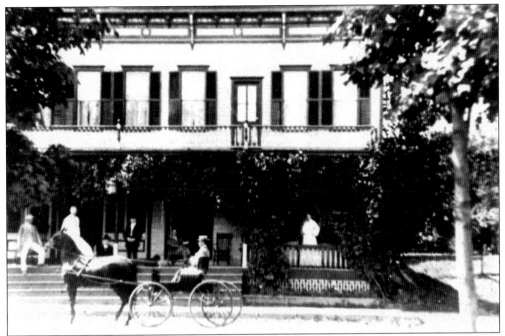

The Central House was built by Peter Westcott of Schenectady in 1892. Richard Mackey, proprietor, is shown with his horse and wagon. The original Central House, built around 1880, burned along with the Gardner and Enders store and the Shoudy House in the 1891 fire.

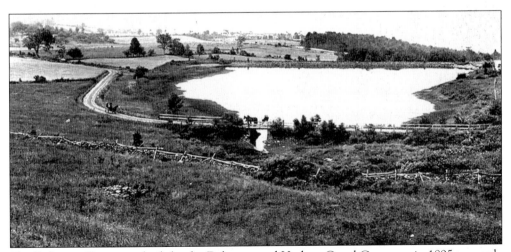

The Delanson Reservoir, built by the Delaware and Hudson Canal Company in 1895 to supply water for locomotives, also provided water to the homes in the village of Delanson. This 1910 view shows Mudge Road around the reservoir. A second reservoir was built further north off Duanesburg Churches Road.

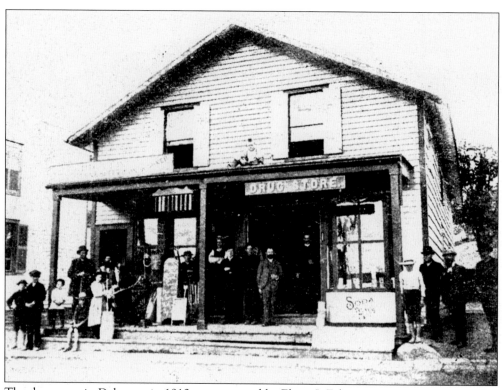

The drug store in Delanson in 1912 was operated by Elmer J. Fake.

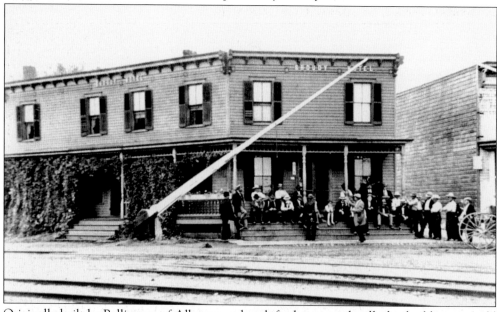

Originally built by Bellington of Albany as a hotel, feed store, and mill, this building was sold to James Shoudy of Kelly Station. After the structure burned down in 1891, Shoudy immediately rebuilt the Shoudy House to accommodate the traveling public as well as the railroad men who stayed over between runs, His advertisement in the *Gazette* of Quaker Street offered "Good Barn, Shed, and Stable, Reasonable Terms and a Barber Shop."

This is an interior view of the building that became known as the Jackson House in the mid-1900s. Constructed in 1883, the building first housed a meat market operated by Emmet Schemerhorn, and then became a restaurant. The structure was also used as an office and residence by Fox and Terpening, dealers in hay and straw. This photograph appears to date from the Prohibition period, for only soft drinks are advertised.

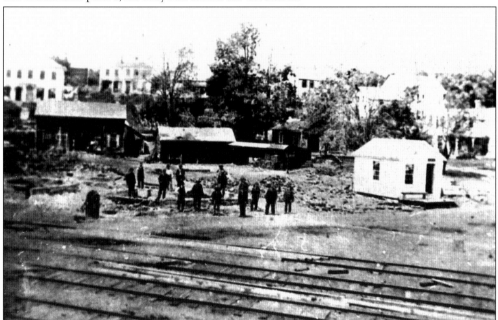

The disastrous fire at Main Street occurred in 1891. The Shoudy House, the Gardner Grocery, the drug store, and the Central House were destroyed. All were soon rebuilt. Note the burned remains of the crossing gates in this view.

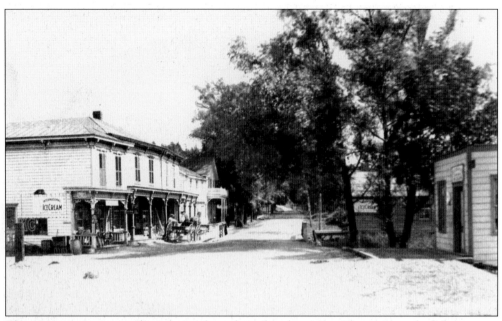

This 1911 picture is a southward view from the railroad crossing. The store on the left was once Henry Liddle's. The building was eventually moved back and became known as the Shotgun House. Floyd Barton and his family lived there when his garage was located to the house's left.

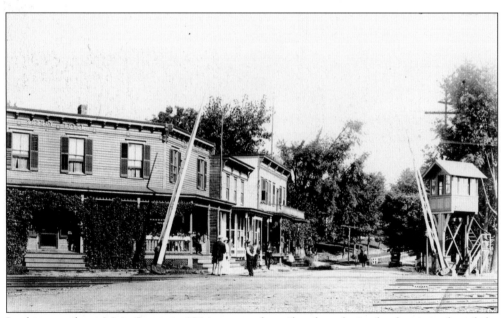

Looking north on Main Street in 1914, we see the railroad tracks in the foreground, and the gatekeeper's house on the right. The larger buildings in this view are, from left to right, the Shoudy House, the drug store, and the Central House.

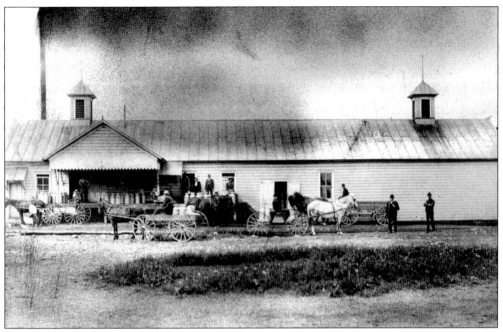

The Delanson Creamery, built around 1880, did good business until 1905. Thereafter, the structure stood vacant for a time before it was taken over by Hunt and Washburn and used for lumber storage.

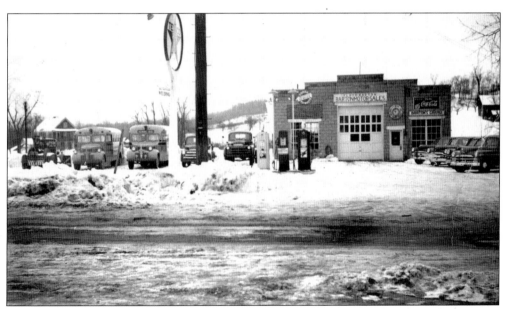

Barton's Garage in Delanson was built in 1927 by Floyd Barton. Barton had a Dodge and Plymouth dealership. He was an excellent mechanic and also serviced the school buses. Sometime after Barton's business folded, the Duanesburg Central School's bus fleet was housed at this location. Several more businesses occupied this space before the Delanson post office moved here in the mid-1980s.

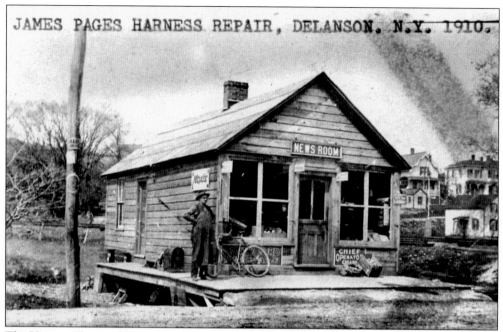

JAMES PAGES HARNESS REPAIR, DELANSON. N.Y. 1910.

The Harness Shop and News Room, operated by James Paige, was located on the southwest side of the crossing.

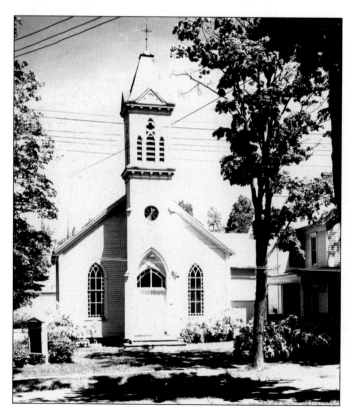

The Methodist church was built under the leadership of Rev. Peter West. David Bolles was contracted on September 2, 1876, to build a church for $23,000 on a lot given by Hicks Sheldon. The church was dedicated on March 1, 1877, and had Rev. G. W. Browne as its first minister.

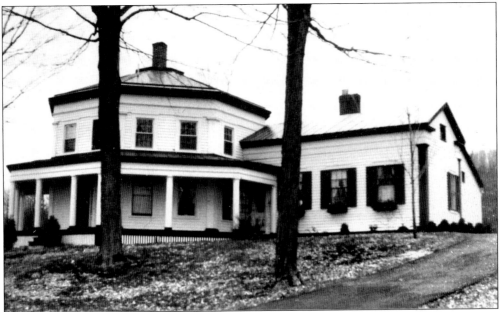

The Jenkins House, one of two octagonal houses built in Duanesburg, was built by Alexander Delos "Boss" Jones for Nathan Jenkins. It is made of rough-sawn boards 1 1/2 inches thick by 5 1/2 inches wide alternately stacked with boards 1 1/2 inches thick by 5 1/2 inches wide, laid up smooth on the outside and rough inside to make a solid wall. The rough inside provided a tooth for plaster, making lath unnecessary. This house is located just north of the village line on Route 395.

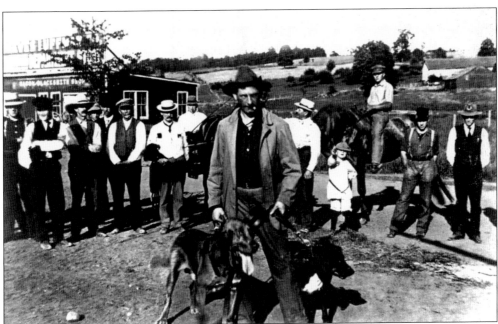

This posse of men gathered in Delanson in 1906 to search for a thug thought to be hiding in a nearby barn after the Jenkins robbery. The small boy was Galen White (1901–1966), son of state senator Loren H. White. Galen became the Delanson undertaker when he grew up.

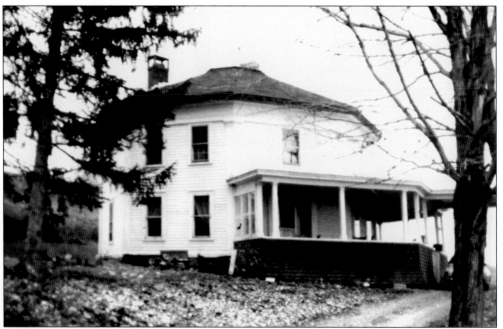

The Shute House, located on McGuire School Road, was built for John Shute by "Boss" Jones. The exteriors of both buildings were sided with vertical board and batten siding, which held up well against the weather. Octagonal houses were the vogue in the mid-1800s, and Duanesburg did not escape that trend. The fad was started by the Phrenologists, a religious sect who claimed they could tell a person's intelligence by the shape of their head and the bumps thereon.

Alexander Delos Jones (1818–1897), best known as a "boss" carpenter, built houses and barns and was also a cabinet maker and farmer; he was meticulous and exacting in all his endeavors. Jones is noted in the area for building the octagonal houses within the town.

Four
MARIAVILLE

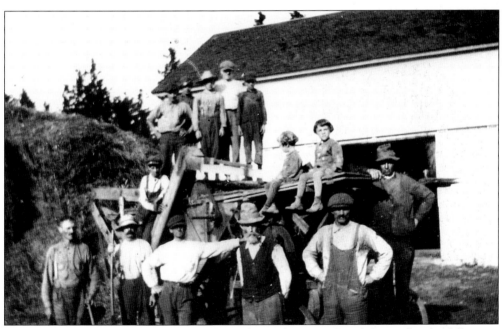

The members of this threshing crew at the Gahagan barn are, from left to right, the following: (first row) Abram Eaton, John Hart, Wesley Gahagan, "Foddy" McKeon, and Richard McKeon; (second row) Alvah McKeon, two summer visitors called "Peck's Bad Boys," and John McKeon; (third row) Dan McKeon, Charlie O'Brien, John McKeon Jr., Clarence Dennison, and Bill McKeon.

In 1806, George William Featherstonhaugh came from his native England to Philadelphia, where he met Sarah, daughter of James Duane. The two were married in St. George's Episcopal Church in Schenectady, and settled near Mariaville on 1,000 acres of land inherited from her father. They built a large estate patterned after an English manor. The house measured 140 feet by 60 feet. Featherstonhaugh was both a gentleman farmer and a scientific farmer. He brought over the best of seeds from Europe, as well as pedigreed animals. He organized the New York State Board of Agriculture, and became the first agricultural commissioner in the United States. Featherstonhaugh was also considered the father of steam railroads in the United States. His two daughters died from diphtheria in 1825, and his wife Sarah died in 1828. His mansion burned May 6, 1829, because of a "fouled" chimney. Heartbroken, Featherstonhaugh left Duanesburg forever. He was appointed the United States' first geologist in 1834, and he took three tours for the federal government, acting as surveyor, explorer, and geologist. One tour went to the Ozarks, another to the Minnesota area, and the third to the Cherokee lands. In 1839, he went back to England. Due to his knowledge of Maine, Featherstonhaugh was sent back to the United States, where he set up the North American boundary commission and settled the territory dispute between Maine and New Brunswick, Canada. He represented both countries and established a boundary that lasted for more than 160 years. Featherstonhaugh returned to England and was appointed British consul for the Department of the Seine at La Havre, France, a job he held until his death. His most notable achievement occurred in 1848, when during the French Revolution, he engineered the successful escape of King Louis Phillipe and his queen—with their heads intact. Featherstonhaugh died September 28, 1866, and was buried in Turnbridge Wells, England. (Photograph courtesy of Schenectady County Historical Society.)

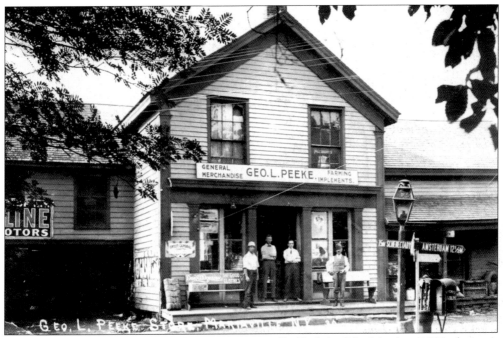

The general store is the center of downtown Mariaville. Built by Silas Marsh in 1831, the store had many successive owners, including the Peeke family, who owned it for two generations. Mariaville was named after James Duane's daughter Maria, who liked to visit this area.

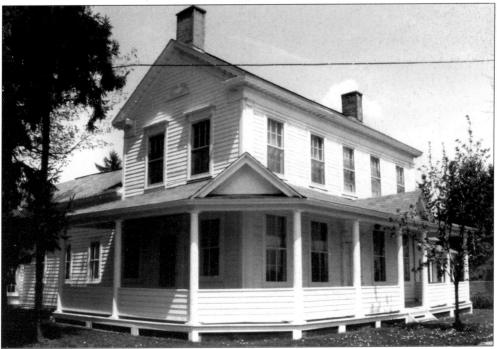

The Frost Mansion, built by James Frost in 1834, was made from reclaimed portions of the Featherstonhaugh Mansion that burned June 29, 1829. The Featherstonhaugh Mansion was located on a ridge just south of Featherstonhaugh Lake.

The Mariaville House was constructed by Jeremiah Murray *c.* 1840. It was destroyed by fire on April 25, 1911. The blaze was fought by a bucket brigade of more than 100 men. The fire also destroyed the blacksmith shop and wagon shop that were attached to the house, as well as sheds, barns, and the church shed. The fire started in the outhouse.

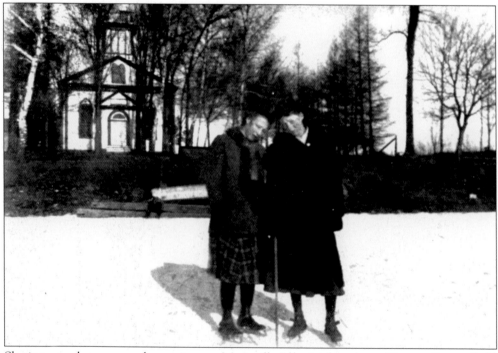

Skating was always a popular pastime on Mariaville Lake in the winter. Eleanor Brown (left) and Helen Walpole stop to have their picture taken in front of the Mariaville Presbyterian Church around 1909, before it was raised up.

This church was originally built as a Dutch Reformed church on land donated by James Frost. It became a Presbyterian church in 1860.

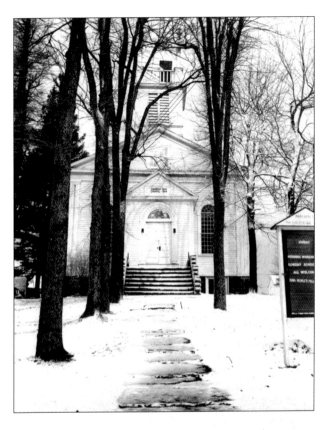

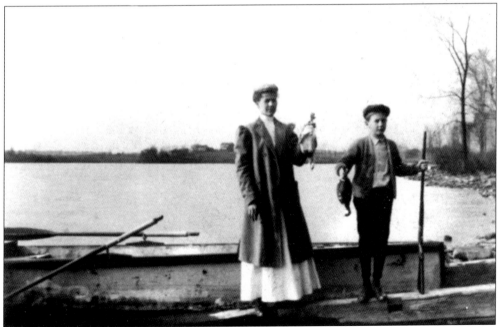

Margaret Parent, wife of Presbyterian pastor Samuel Parent, stands with son Ralph as they proudly show off the evidence of a successful hunt.

The Mariaville Causeway is viewed here in the early 1900s, before the state road was built in 1911.

The dance hall in Mariaville was built in 1919 by a Mr. Tucker, who owned a newsroom in Amsterdam. Tucker sold the dance hall to Dominic Salamack in 1921. It became a real hot spot during Prohibition, and scores of cars came into Mariaville when big bands were scheduled to perform there.

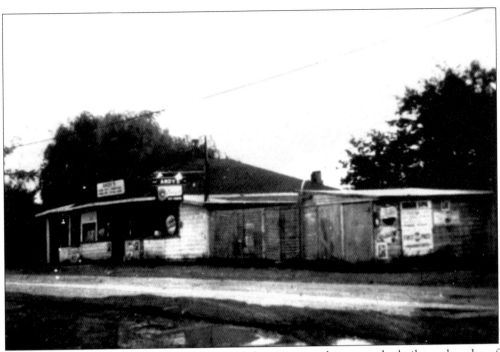

Dominic Salamack sold beverages, gasoline, and groceries at this tavern he built on the edge of the lake in the early 1920s. The establishment was later sold to John Ferris.

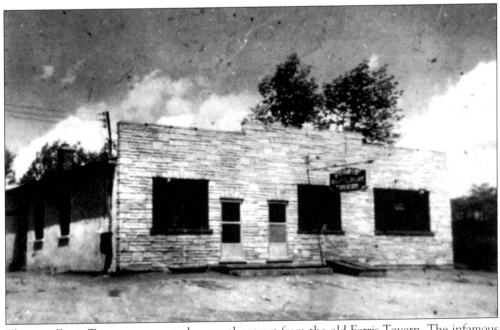

The new Ferris Tavern was erected across the street from the old Ferris Tavern. The infamous creature known as the "Mariaville monster" was stuffed and hung behind the bar, and was cremated when the tavern burned. The Mariaville monster was a hoax; it was actually a wolffish that had been caught off the coast of Massachusetts.

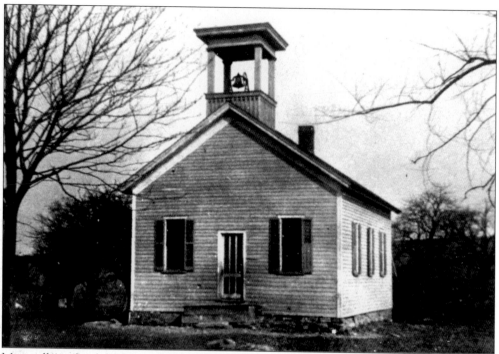

Mariaville's school, built in 1885, consisted of one room for eight grades. It was located in the wye at the corner of present-day Route 159 and Route 160. It burned in 1925. Classes were held in the Ondawah Inn from 1925 to 1927, while the new school was being built.

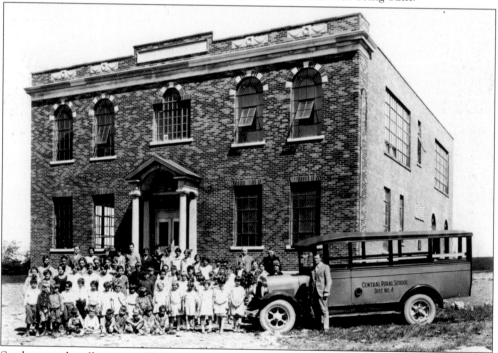

Students and staff are assembled in front of Mariaville's new Central Rural School, which was completed in 1927. On the right are driver Howard Wood and the new school bus.

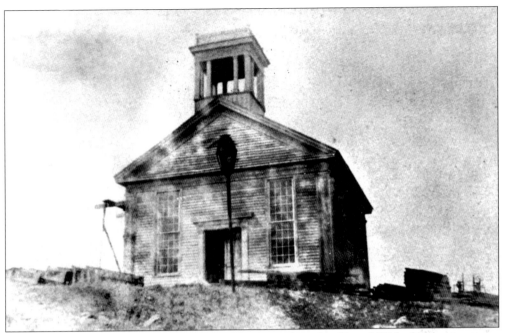

The Methodist church was built in 1860 and was purchased by David Walpole after it was no longer used as a church. Walpole converted it into a meetinghouse and election hall. After Walpole's death, his daughters made it into a summer home and named it the Ondawah Inn.

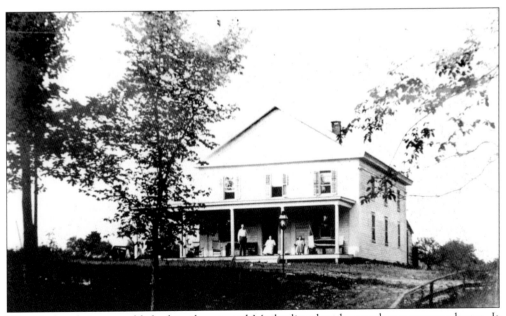

The Ondawah Inn, established in the unused Methodist church, acted as a summer house. It was known for its excellent home cooking and its access to swimming and boating. In 1924, Mary B. W. Noon and Mrs. Walter H. White were listed as the hostesses. The weekly rate for guests was $11 for two adults, and children were charged according to age.

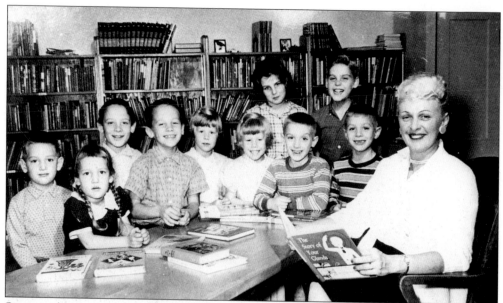

Six sets of twins were attending school in Mariaville in 1963. Shown in this image are, from left to right, the following: (first row) the Sulyok twins, the Paige twins, the Ruther twins, the Piotrowski twins, and Lois Troup; (second row) the Massoth twins. Missing from the photograph are the Weakley twins.

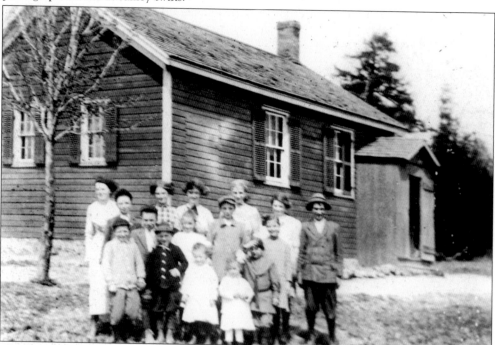

The Eaton School was another one-room school closed by consolidation. On January 2, 1937, the building was moved from its location on present-day Route 160 (the Cotton Road) to Mariaville, where it became the community's firehouse. After the construction of Mariaville's new fire station, Harry Mott took portions of this old structure to build his garage. Notice little Edna Eaton in the foreground of this c. 1905 photograph.

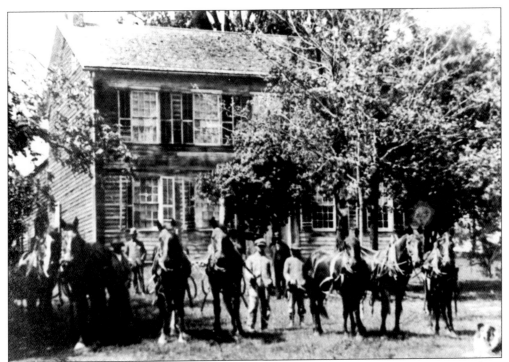

Farmers of long ago gathered together to do chores of harvesting, threshing, cutting ensilage, and haying. Here, work crews with their teams of horses are gathered, ready for a day's work on the Culver (Hiram) Patterson Farm. The farm is located on Levey Road, which bordered on the Montgomery County line.

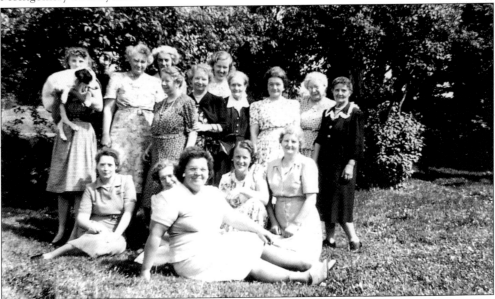

Members of the Mariaville Ladies Club are shown here. From left to right are the following: (first row) Margaret Martin, Myrtle Gutha, unidentified, Ruth Sandora, and Irene Geores; (second row) Martha Van Buren, Julia Turnbull, Mary Pangburn, Margaret Wood, Mary Noon, and Marguerite Swart; (third row) Virginia Wood, Ethel DeRidder, Clara Pangburn, and Leona Smith.

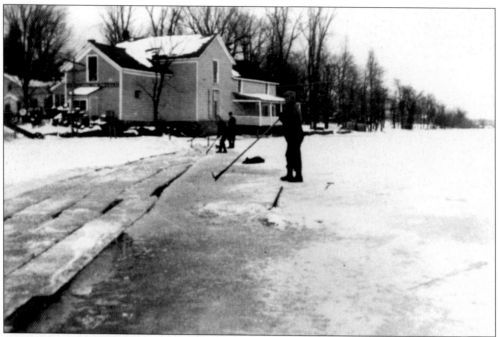

Ice cutting and harvesting on Mariaville Lake was one of this community's important industries. Clyde Cullings is seen cutting ice behind the general store in Mariaville.

After the ice was cut, this elevator loaded the ice blocks onto trucks for transport to one of the several icehouses located in Mariaville. One icehouse was located on Weast Road on the T. C. Swart Farm. Ice was packed in sawdust to preserve it. The ice was eventually shipped to Schenectady and used as a refrigerant in the summer.

Winters can sometimes be severe in Mariaville. This homeowner on Batter Street found that it was easier to tunnel through the snowbank than to climb over it.

Squire David Walpole owned the gristmill, cider mill, broom handle mill, sawmill, triphammer, blacksmith shop, and cheese factory in Mariaville. He also was justice of the peace from 1873 until his death in 1909.

Norman Smith, a lifelong farmer, lived at the old Lasher place, also called Rainbow Hill, on Levey Road. His son Clarence Smith continued the family farm until he died in 1973.

Grandma Susie Anna Jones and her granddaughter Edna Eaton are dressed in their Sunday best. Grandma Jones sewed most of the dresses for Edna and her sisters. She was known for her wonderful chicken dinners made from the fattest roosters or Rhode Island red hens grown on the farm.

The Wycoffite Church was a progressive sect of the Dutch Reformed Church that was started in the nearby town of Charleston by Henry V. Wycoff about 1820. The sect spread throughout the area and even went so far as to affect the Dutch Reformed Church in the Netherlands. The Wycoffite movement peaked in about 1845.

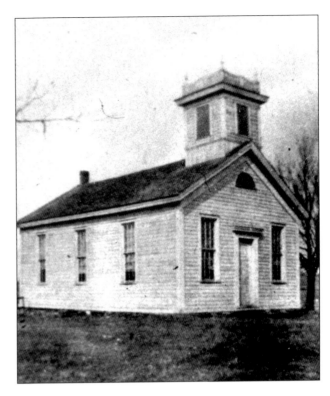

The Wycoffite Church ceased to exist in Mariaville around 1915, and Elmer Marclay bought the church building and remodeled it into a fine home.

This gristmill was built by Silas Marsh around 1831. It was famous for its buckwheat pancake flour, which was served in fine restaurants throughout the country until the mill closed in 1920. The gristmill was one of a complex of industries that Silas Marsh brought to Mariaville. Among Marsh's other enterprises were a sawmill and the general store.

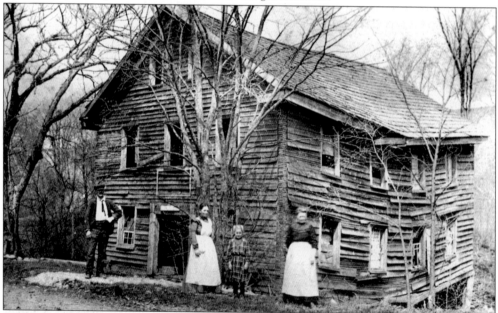

The Green Woolen Mill was located at Green's Corners, where Wells Road and North Road intersect Route 159. The Green family migrated to Mariaville in 1792 from Duchess County. Because the mill was built on beams that spanned the South Chuctanunda Creek, a waterwheel could be used to power both a sawmill (downstairs) and a woolen mill (upstairs), which produced woolen blankets. Standing in front of the mill are, from left to right, C. A. Cullings, Minnie Thorton Cullings, Kathryn Cullings, and Elizabeth Thorton. The mill was razed in 1911.

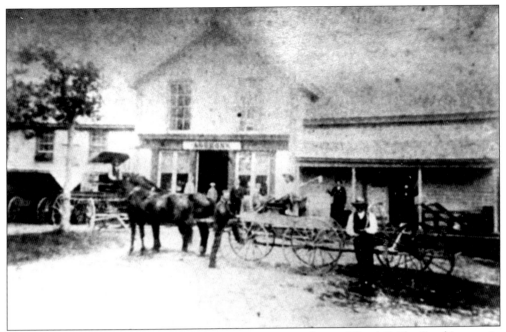

Clarence Alva Cullings, better known as C. A., poses in front of "Little" Abe Brock's store in 1893 with his special wagon that had three axles and six wheels. Cullings brought the first load of telephone poles to be used in building the network of the Mariaville and South Schenectady Telephone Company. It was Schenectady County's first rural telephone company.

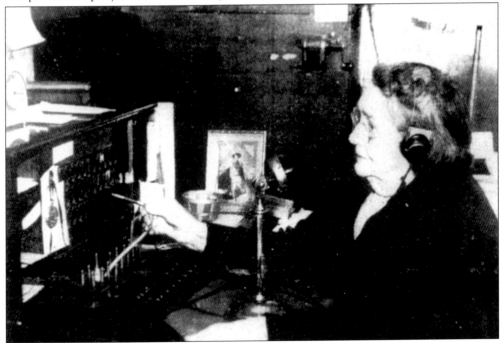

Minnie Cullings, C. A.'s wife, was the chief operator, president, and bill collector of the Mariaville and South Schenectady Phone Company. C. A. Cullings was the lineman, manager, and treasurer. He continued to be the lineman until his death at the age of 78.

The ice storm of January 1943 destroyed many of the telephone company's 1,400 poles and left more than 100 miles of wire on the ground. C. A. Cullings died of a heart attack after viewing the devastation.

C. A. Cullings' son, Clyde, who ran both the Mariaville garage and Mariaville bus company, eventually assumed responsibility for the operation of the telephone company. He was assisted by his wife, Marge, and their children, Joanne, Clyde, and Nancy. Marge, Joanne, and Nancy became operators.

Eight-year-old Nancy Cullings became the world's youngest telephone operator, while her brother, Clyde Cullings Jr., followed in his father's and grandfather's footsteps and became a lineman at the age of 13. Clyde Cullings Sr.'s death in 1948 and another ice storm in January 1949 forced the Mariaville and South Schenectady Telephone Company to close.

Original Mariaville fire department members are, from left to right, the following: (first row) Dominic Salamack, John Shurer, George McKeon, and Jimmy Guthinger; (second row) Richard "Rit" McKeon, Carl Geores, Arnold Lester, Leo Martin, Senator Miller, and Clyde Cullings.

A settlement sprang up near the intersection of present-day Batter Street and North Road after the Revolutionary War. The Conklin Hotel, constructed by Capt. Abram Conklin, was one of these buildings. During the War of 1812, Conklin had a training ground for soldiers across the road from his house. Also nearby were the Sherburne Tannery and the "White" Meeting House.

Following the Revolutionary War, Capt. Elijah Herrick moved to Batter Street near Mariaville, where he built this house next to the Revolutionary War Cemetery. Captain Herrick was a Baptist preacher, as was his son Pvt. Elijah Herrick, who emigrated to Charleston. Both Captain Herrick (d. July 18, 1806) and his wife (d. June 4, 1829) are buried in the Batter Street Cemetery.

Five

CREEKSIDE

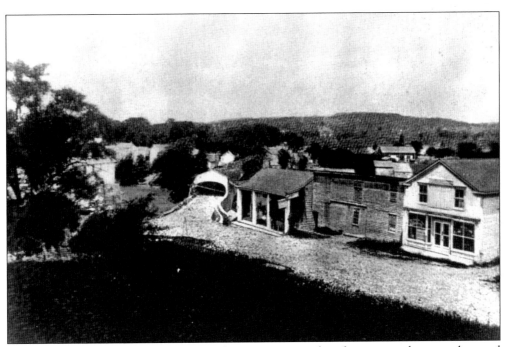

The Brooklyn Hotel, built in 1779, was a favorite stopping place for stagecoaches, travelers, and drovers. It was taken down in 1928 to make room for Route 20.

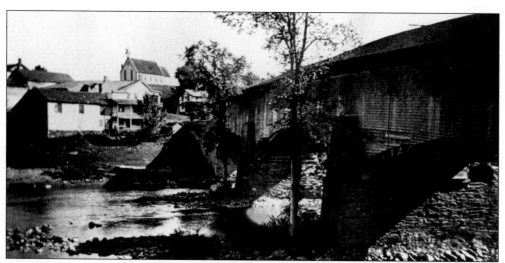

This photograph was taken from across the crick at Esperance. In view are the Esperance Bridge, the Brooklyn Hotel (middle left), and the Episcopal church (upper center).

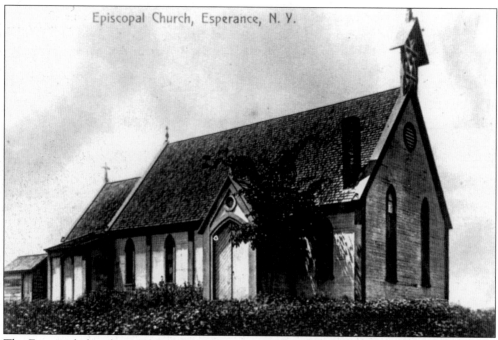

Episcopal Church, Esperance, N. Y.

The Episcopal church, or Trinity Chapel as it was sometimes called, was built in 1877 mainly through the efforts of the Duane family. The church closed around 1910 and was taken down by W. F. Tiffany in 1924. Notice the unique steeple. The organ in the church was pumped by hand and occasionally the organist would run out of air because the man who operated the pump fell asleep.

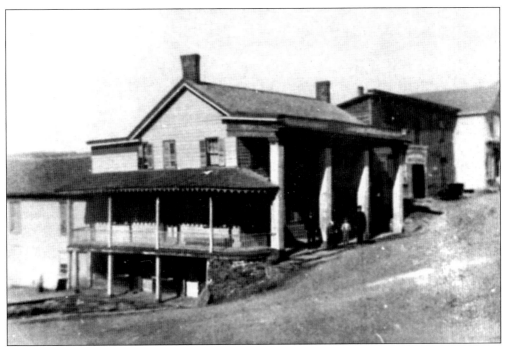

This view shows the entrance ramp to the Esperance Bridge, the Brooklyn Hotel (center foreground), and the blacksmith shop and store. These were the all-important conveniences for the early travelers along the toll road—the Great Western Turnpike—now Route 20.

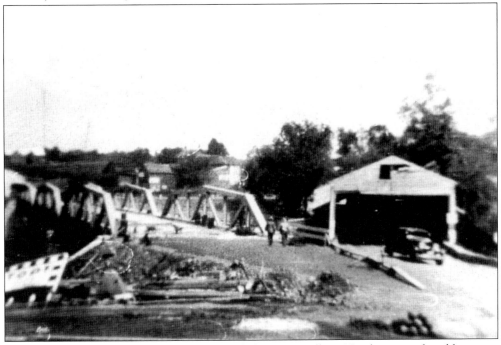

The Esperance covered bridge (on right), built by Gen. William North, was replaced by a new bridge (on left) in 1929. At first, officials tried to tear down the old covered bridge, but it was so well built that they finally resorted to burning it down.

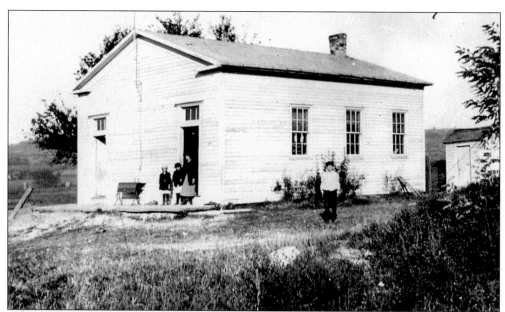

School District No. 10, known as the Gibson School, was built in 1851 by George Wright for $298. The schoolhouse was located on Route 20, just west of the intersection at Route 30. Benjamin Duane, Jacob Gardner, and Lewis Avery were trustees of the district at that time.

Young's Store was located on what is now called Young's Road. The business flourished from 1801 to 1821 and was owned by John Young, who was also a landlord, farmer, and operator of a limekiln. Since money was scarce, the locals practiced a barter economy. Young made loans on notes and paid off notes by collections; even wood ashes were a salable commodity. This building was removed in 1972.

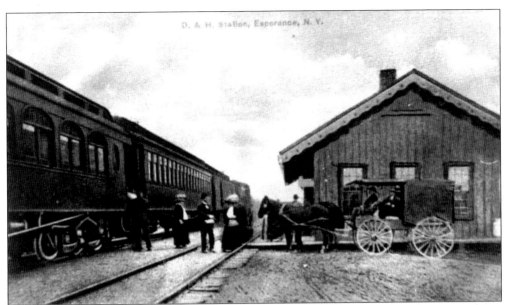

The Albany and Susquehanna Railroad had reached Esperance Station by 1864. It was originally a broad-gauge railroad, which means there was a distance of six feet between the rails. Later, after the Delaware and Hudson took over the railroad, the line was converted to a standard-gauge railroad, which means the rails were set four feet eight and one-half inches apart. This standard measure was set for United States railroads by Congress in March 1863.

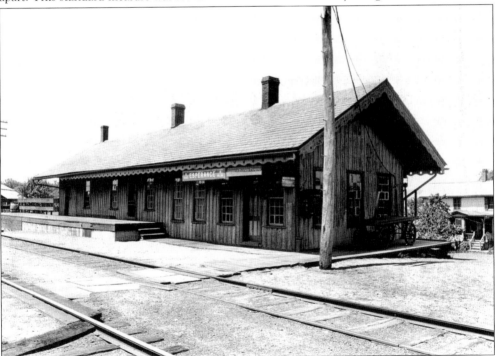

Esperance Station was both a passenger station and a freight station, as well as a mail drop-off. Much hay was shipped from Esperance Station in the early days, and several hay barns were located nearby. The station was closed in 1935 and torn down shortly thereafter.

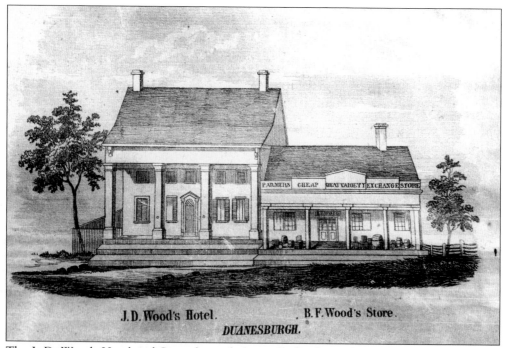

The J. D. Woods Hotel and Store, located alongside the Great Western Turnpike, provided services for travelers and locals alike.

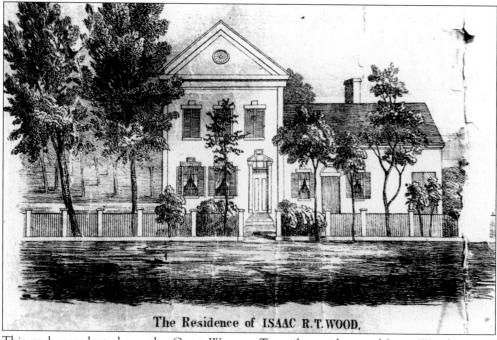

This early woodcut shows the Great Western Turnpike residence of Isaac Wood, one of Duanesburg's prominent citizens.

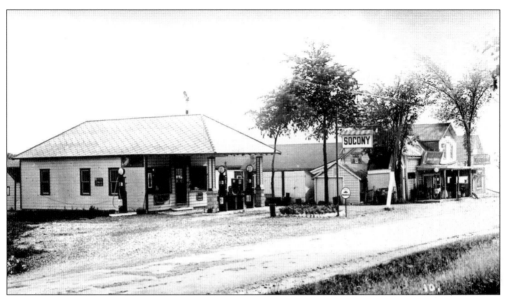

The original service station at the far right was built in 1905 by William F. Tiffany. Later, a showroom was included for selling Ford automobiles, and after that, Plymouths and Chrylsers were added to the inventory. Farm machinery, hardware, kitchen appliances, and eventually televisions were sold here. The gas station at the left was built in 1930.

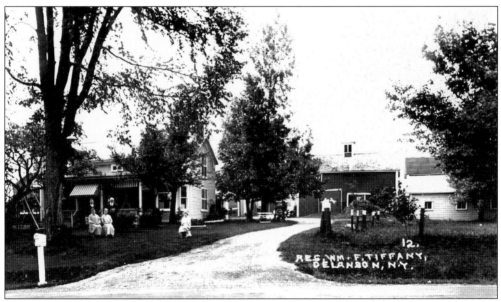

The home of William F. Tiffany stood across from Tiffany's gas station, on Route 20. In this 1920 photograph, family members are gathered in front of the house. Standing are William F. Tiffany, on the right, and his son, James, beside him on the left. William's wife, Luella, is seated in front of him on the right, and Luella's sister Conine is seated to the left of her. William's young daughter, Ella, is seated to the far right, next to the driveway.

Delanson Rural Mail Route No. 1 was established October 1, 1903, with Witmer Gardinear as the carrier. Here, he has stopped at the Robert Liddle home on McGuire School Road while making his rounds. Gardinear worked on this route until December 31, 1911.

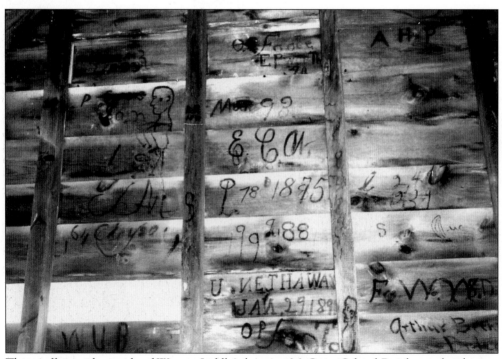

This graffiti on the inside of Warren Liddle's barn on McGuire School Road reveals a history of what happened here. Generally put on with a mixture of lampblack and water, the graffiti lasted for years. Notice Mr. Nethaway's "N"s in the lower center part of the picture.

Amy Clayton, a peddler from Burtonville, often could be seen wandering through the town of Duanesburg. He supported himself by selling pins, needles, thread, shoelaces, toothpaste, tape, pills, and White Cloverine Salve, a cure-all for ailments. A tall man with black hair and large feet, Clayton scared many children and housewives. However, most residents welcomed him into their homes, where he was able to sample the home-cooking of his customers.

In this view across the Schoharie Creek, one can see Burtonsville in the background and two spans of one of the many bridges that crossed the creek in this area. The first span (in foreground) is a steel structure; the second one is a cast-iron whipple bridge (of Erie Canal fame) that replaced the original old covered bridge.

Tulloch's Tavern, owned and operated by John Tulloch, was a very busy place around 1850. Farmers from the town of Charleston would stop there overnight on their way to Albany. Long lines of their wagons, loaded with grain and other produce, would be parked along the side of the road from the top of the Burtonville hill to the foot of the Eaton's Corners hill.

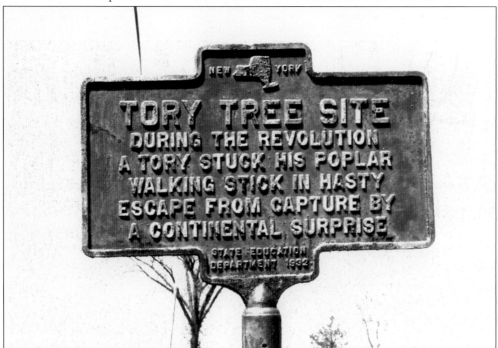

NEW YORK

TORY TREE SITE
DURING THE REVOLUTION
A TORY STUCK HIS POPLAR
WALKING STICK IN HASTY
ESCAPE FROM CAPTURE BY
A CONTINENTAL SURPRISE
STATE EDUCATION
DEPARTMENT 1932

This sign located along Eaton's Corners Road denotes an event of importance during the Revolutionary War. Detailed knowledge of occurrences in Duanesburg related to the war are limited as a result of two fires in which town records were lost.

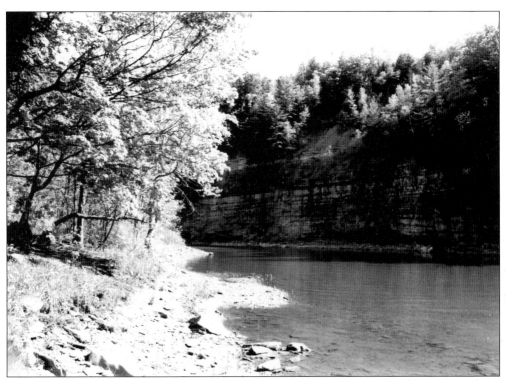

This is a scene of the Schoharie Creek at Cummings Hollow, probably one of the most beautiful spots in the town of Duanesburg.

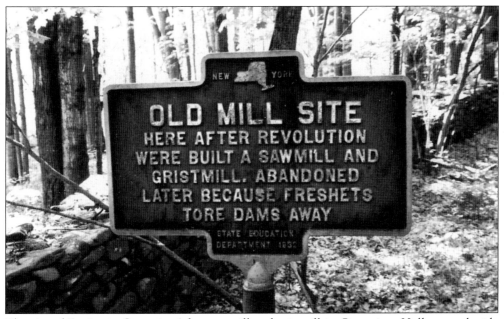

The site of Benjamin Cummings' first sawmill and gristmill in Cummings Hollow was beside the Schoharie Creek. The Cummings mills were later moved to Schenectady after a spring freshet washed out his dam.

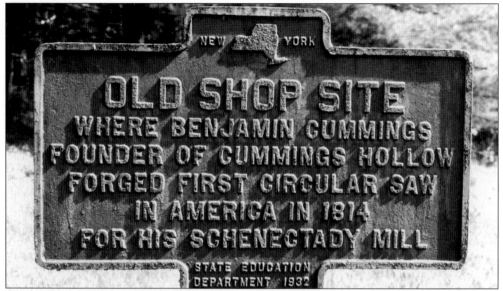

Benjamin Cummings made the first circular saw at his blacksmith shop. Cummings never applied for a patent, and hence he never received any money or recognition for his invention.

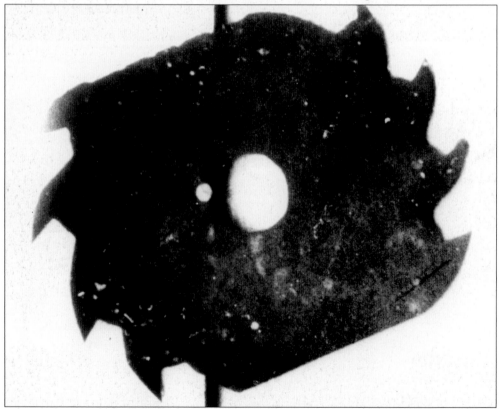

This is a picture of Benjamin Cummings' first circular saw; it was made from an up-and-down jigsaw. It was six inches wide across the flats, and seven and one-half inches in diameter. Think of how this invention changed the lives of every man, woman, and child on planet Earth.

The students of Duanesburg District No. 12 are gathered with their teacher, Carrie Eggleston, and district superintendent James Wingate in this May 1916 photograph.

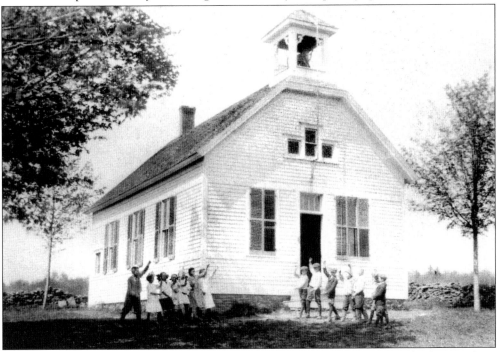

The children of Braman's Corners enthusiastically pose for this 1916 photograph of Duanesburg District No. 24.

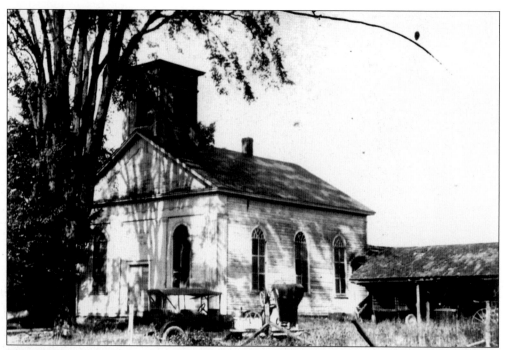

This picture of the Universalist church at Braman's Corners was taken about 1924. This church building was disassembled piece by piece and moved to the town of Nassau, where it was reassembled. Braman's Corners was originally called Parlor Street.

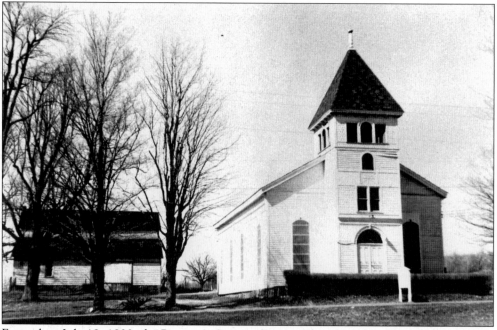

Formed on July 19, 1800, the Braman's Corners Baptist Church is the oldest Baptist church in Schenectady County. In the past, its membership included slaves, and at one time the church even accepted gifts from a Tory. The Braman's Corners Baptist Church is still very active today.

Six
PRINCETOWN SOUTH

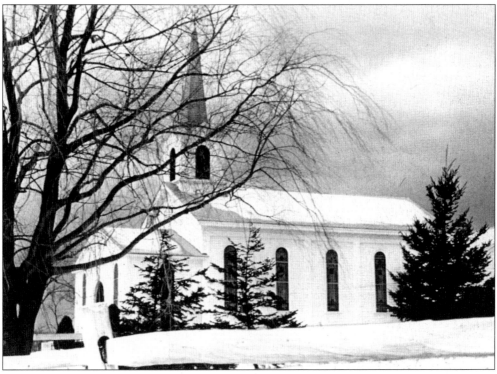

The Princetown Reformed Church at Giffords was officially named the First Reformed Protestant Dutch Church of the Town of Princetown. The sanctuary was built and dedicated in 1873. Organized as a church congregation in 1821, the first church building served for 50 years on this land, which was given by Mydert VanDerVolgen. The church hall was built in 1894. The building was destroyed by fire March 29, 1978. A new building was erected on the site and is now known as the Princetown Evangelical Presbyterian Church.

Adam and Laura Levey Gifford (pictured) were married on March 11, 1896. The first Giffords to settle in the area were Thomas Gifford and his wife, Ann Cowan, who arrived from Scotland in 1784 and made their home in Princetown, then known as Corry's Bush. The couple had 10 children. They are the progenitors of the Giffords in the town today.

The McClaines settled in the southern section of Princetown. The family was always active in the politics of the town. Leland McClaine ran a turkey farm on Giffords Church Road for many years. Family members pictured here are, from left to right, the following: (first row) George, Robert, and Bertha (Shafer) McClaine; (second row) Ida, Merlin, Ruth, Ethel, Leland, and Esther McClaine.

This old tavern was located at Giffords on the Cherry Valley Turnpike (the Great Western Turnpike). It was built in 1784 and was run by the Gifford family. In 1816, it was owned by Calvin Cheeseman. The tavern was a stop for drovers on their way to Albany with their cattle.

This is the back view of the Gifford Tavern. A ballroom was located on the third floor. It was also a post office.

This picture of the ash pits at the Gifford Tavern was taken after the building was torn down. In earlier times, ashes were saved and used in soap making.

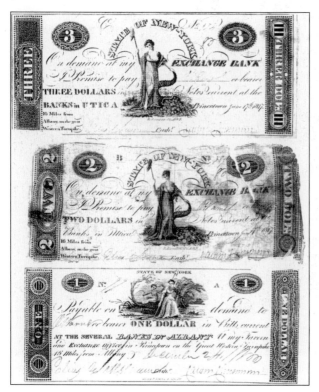

Tavern owner Calvin Cheeseman was known as the "shinplaster banker" because he issued paper money for the convenience of his neighbors and travelers. Silver coins were often scarce and "tavern money" in sums under one dollar took their place.

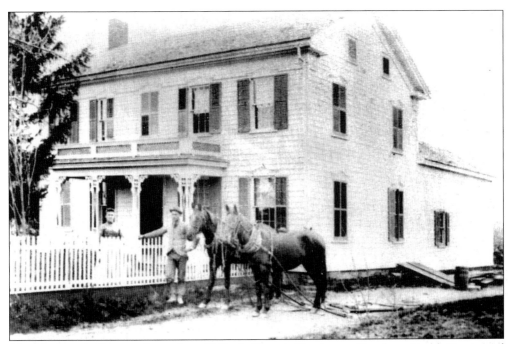

The Hasbrouck House is located on Giffords Church Road, near Pangburn Road. Nettie and James Wemple are seen in this picture taken in the early 1900s.

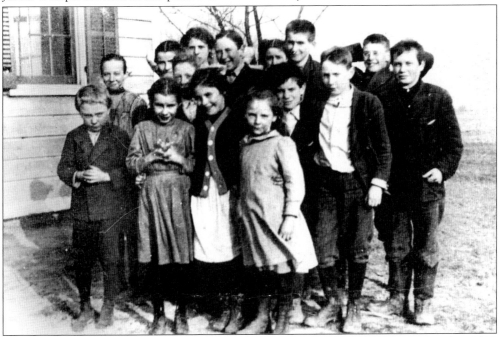

The District No. 1 School was located on Giffords Church Road. Shown in this 1913 photograph are, from left to right, the following: (first row) George Tolles, Evelyn Livingston, Susie Gifford, and Helen McDougall; (second row), Violet Tolles, Kenneth McDougall, Hans Herzog, and Levey Gifford; (third row) Florence Livingston, Stella Bond, Harlen Gifford, Myrtle Gifford, Merton Livingston, Earl Gray, and Bill Herzog.

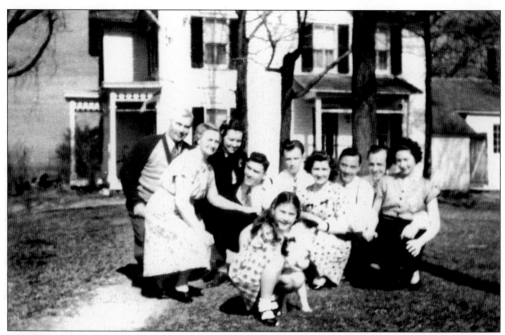

Members of the Walter Ferguson family pose by their home on Darrow Road in Princetown c. 1940. From left to right are the following: (at front) Walter, Bertha, Myrna Quant, Stanley, Frank Holub, Marie Kelley, Whitney, Salvatore Matarazzo, Marguerite, and in front, Ethel Jean.

The Ferguson family is gathered for this photograph at Lake George in 1929. Ellen Ferguson is at the far right in front; she was Walter Ferguson's mother. Walter was a descendant of John Ferguson and wife Jennet Cowan. They came from Scotland and settled in the town in 1775. John built his first log cabin where the family cemetery is now located.

This is the old District No. 7 schoolhouse, located on the corner of Pangburn Road and Birchwood Drive. It was replaced by another school building, which is now a residence.

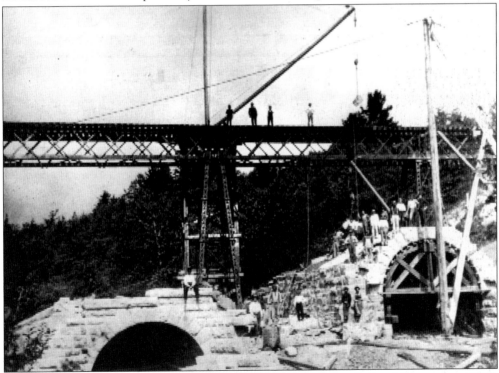

The trestles at Kelly's Station, built by the Delaware and Hudson Railway Company in 1895, were constructed from cut limestone. The culvert allowed the swift-flowing Normanskill to pass under the railroad tracks. Amassing the large amount of fill needed for the railroad to achieve a grade must have been a major engineering feat for its time. A similar culvert was also constructed at Bonny Brook.

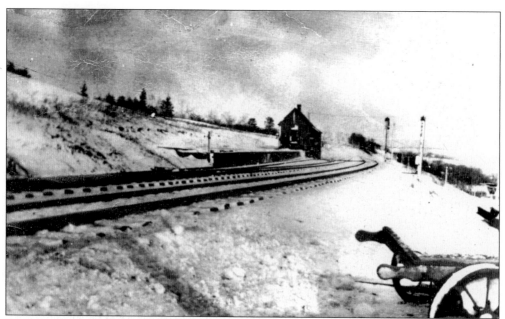

The little railroad depot at Kelly's Station sat beside the tracks of the Delaware and Hudson Railroad. Otis Tulloch started as a telegrapher there at the age of 16. (He had first applied for the job when he was 14, but was told to come back in two years.) After he was hired, Tulloch remained working there until the station closed sometime during the Depression. The depot was torn down and the boards were used for the Tulloch home on Kelly's Station Road.

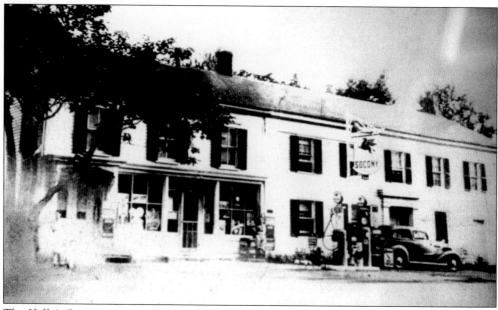

The Kelly's Station store and post office, located at Kelly's Station on Duanesburg Road, was run by J. Gifford in 1798 (the year the town was formed). The business was later purchased by Andrew Kelly, and later, by Alfred Vedder. Walter and Alma Vedder are in front of the store. The Normanskill runs behind this building.

Jennie Kelly Vedder, born in 1875, was the daughter of Andrew Kelly. She married Alfred Vedder and was postmistress at the store and post office at Kelly's Station. Andrew's father was Solomon Kelly, who was well known as a master carpenter and the builder of the Duane Mansion in Duanesburg. Their ancestor William Kelly came from Edinburgh, Scotland, in the mid-1700s.

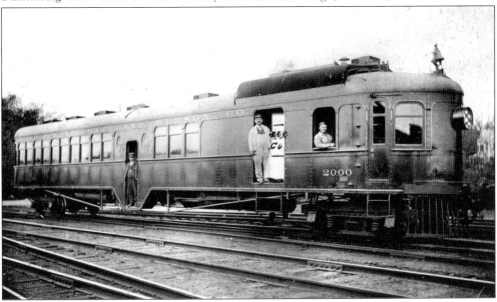

Jennie Vedder remembered when this old Delaware and Hudson diesel-engine passenger train was called "the Skunk" because of its foul smell. Manufactured by the General Electric Company in Schenectady, this train was sold after the Depression and ended up in California, where it was still called the Skunk. Jennie picked up the mail daily at the railroad station across the road from the store at Kelly's Station. The mail was then sorted and distributed to customers.

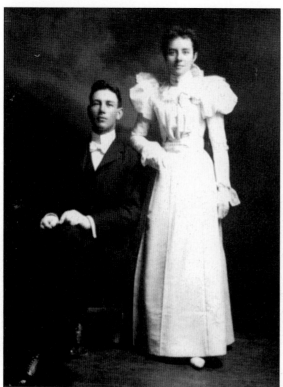

Jacob and Bertha Levey Vedder were married in Princetown *c.* 1895, at the home of the bride's father, Peter Levey. A newspaper article described the bride as "one of the most popular young ladies in the Reformed Church of Giffords" and the groom as "a prosperous young man." The new Princetown town hall stands on what was once their land.

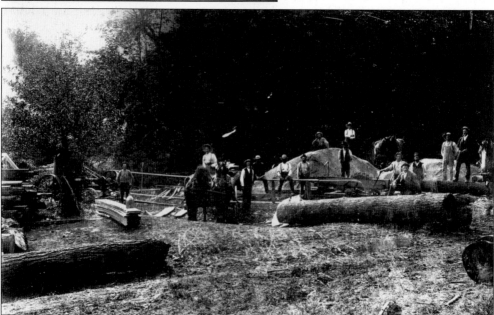

This sawmill, located at Kelly's Station near the trestles, was probably situated on what was later the William Lee property. This was one of several sawmills located in Princetown. Neither the year nor the names of the men in the photograph are known. Sawmills were very important to the town. Farmers cut down their trees and brought them to the mill to be made into lumber to build their houses and barns.

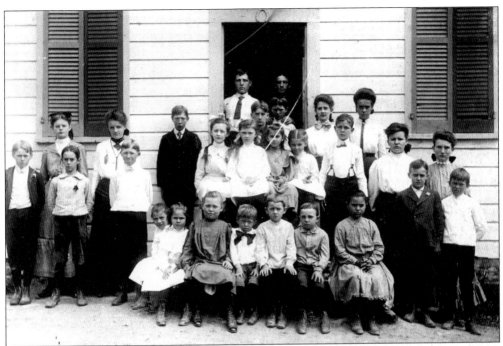

The District No. 2 School was located on Kelly's Station Road. In this 1904 picture are Otis and Grace Tulloch; Elmer, Arthur, Walter, Chester, and Wylie Looman; Maude, Harry, Abram, Sada, Helen, and Raymond Kelly; Clinton, Florence, and Clarence Wilbur; Tully and Walter Robison; Mary and Ethel Stewart (Stuart); Laura and Lina Mae Liddle; Lena and Rosa Gus Stevens; Emmett and Ethel VanValkenburgh; Grace Hunter, and Bertha Norton.

This photograph was taken near the District No. 2 School. The teacher is Amy Dietz, and the pupil is Marjorie Mann. Teachers usually boarded around with local families. It was there that they learned not only the problems of their pupils, but also the family secrets.

This barn on Duanesburg Road was probably used as a hop barn. The cupola allowed the surplus moisture to escape. Most hops were grown in Schoharie County, but some were grown in Princetown and Duanesburg. This barn, built in 1900, was a favorite stop for hobos who got off the trains at Kelly's Station. The farm had a reputation as a good place to get a meal.

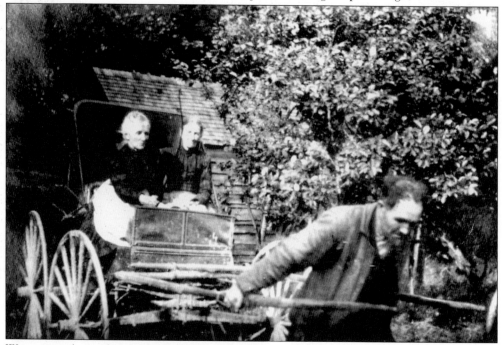

We can see here who the bosses were in the Turnbull family. James Turnbull pulls the cart while Agnes Turnbull and Aunt Rosie take a ride. The Turnbulls were relatives of the Mabens of Maben Road in Princetown.

Seven
PRINCETOWN CENTER

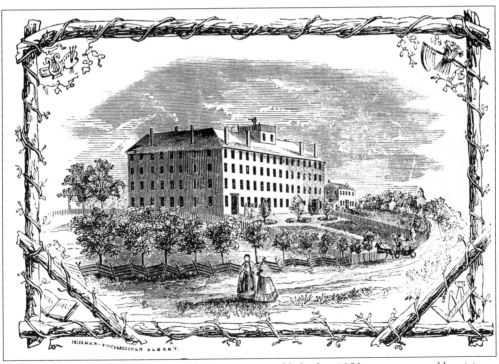

The Princetown Academy and Female Seminary, established in 1853, was sponsored by citizens of the town and members of the Presbyterian Church. It was said that the coeducational institution, with an enrollment of 382 students, was built because the well-to-do people of Schenectady wanted a school located far enough out of town for their children to escape the bad influences and wildness prevalent in the city. Sometime between 1856 and 1860, the institution closed and was removed.

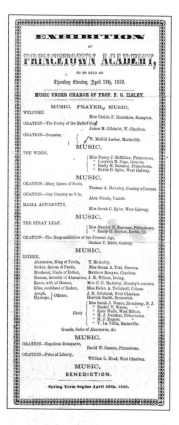

An exhibition program from the old Princetown Academy shows that faculty members from Union College in Schenectady also taught at Princetown. Pupils came from as far away as Cuba, Scotland, and Germany. The academy was referred to as "truly American and republican," and an "institution of high moral and religious character."

The old Liddle House is located on Maben Road and is probably the oldest house in Princetown. It was built by Robert "Old Rabbie" Liddle, who was a shepherd and a stonemason from Scotland. Robert lived in a log cabin on the edge of the Normanskill for 19 years while he cleared his land and built his home. Erected in 1790, the house was constructed of stone quarried from the Normanskill.

The Princetown Presbyterian Church was built in 1816. Two other Presbyterian churches, dating back to the late 1700s, were located on other sites. This church features stained-glass windows with the names of former parishioners. The chapel was built in 1890. The church, located on Currybush Road, is now the home of Community Fellowship.

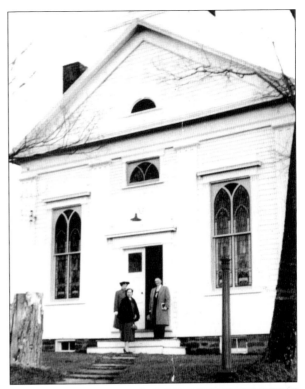

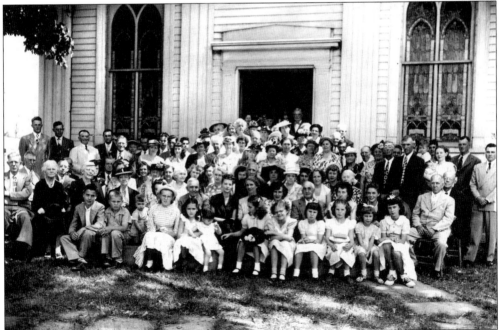

Members of the Princetown Presbyterian congregation pose by the church on Old Home Day in the early 1950s. The minister was Rev. Harry Swan. Held each year in August, Old Home Day was an occasion when former parishioners would return to their old church. At one time, the Princetown congregation was one with the Reformed Presbyterian Church of Duanesburg.

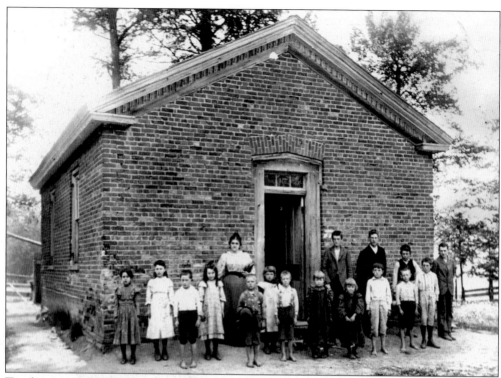

Teacher Mrs. Lyke (back row, to left of doorway) of District No. 3 School on Kelly Road poses with her students of 1897. From left to right are the following: (first row) Pearl Bradshaw, Dora Gordon, Theodore Gordon, Irena Weast, Joseph Scheuer, Anna Scheuer, Earl Jones, Beulah Springer, Emma Springer, Robert Bradshaw, John Bradshaw, John Charist, and Almon Weast; (second row, to right of doorway) Nielson Hannah, Robert Tulloch, and James Weast. Notice the boys have bare feet.

Felix Stremel sits in his old jalopy on his farm in Princetown, probably in the late 1930s. The boy at the left is Donald Jones, the girl is unidentified. Stremel's parents came over from Lithuania in the early part of the 20th century. The Stremels moved into the old Turnbull place in 1931.

James Wingate was born in Princetown in 1872 and graduated from Union College in 1897. He taught in rural schools and became commissioner of schools in Schenectady County. In 1932, Wingate went to work for the Motion Picture Producers and Distributors of America, known as the Will Hays organization, in Hollywood.

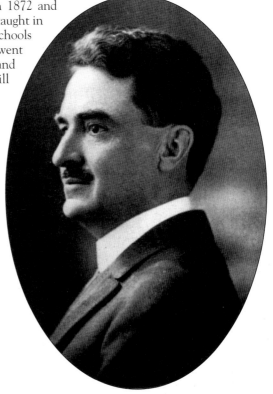

These farmers have gotten together to saw some wood in March 1942. From left to right are Robert Wingate, James Wingate, Maynard Abbuhl, Roy Looman, Werner Feuz, and John Knutti.

This house, located on Skyline Drive in Princetown, was built by George Featherstonhaugh in 1814. It is now owned by the Armstrong family.

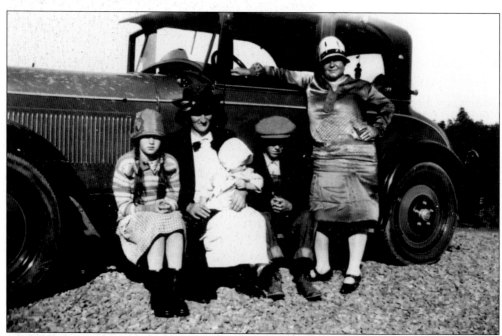

Jacob Knutti came from Switzerland and settled on a farm on Pangburn Road in Princetown. Knutti family members seated in this picture are, from left to right, Clara, Ida, baby Walter, and John. The woman standing is unidentified. The year is probably 1926.

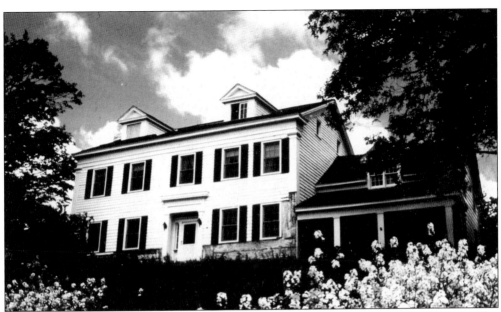

The Bradshaw House was built in the latter part of the 18th century. James Bradshaw and his wife, Elizabeth Bullock, were from England. In 1776, they purchased from John Duncan a 500-acre tract situated partly in Princetown and partly in Duanesburg. A small house was built with a hideaway, presumed to be an escape passage between two buildings. The home was occupied by James Bradshaw Jr. until his death in 1858, and it remained in the family until 1930.

Walter Bradshaw was born on the family farm in Princetown in 1837. He was a descendant of James and Elizabeth. Walter was supervisor of the town for 12 years and also was an elder of the Princetown Presbyterian Church. He died at the home of his only son, James Allen Bradshaw, of Schenectady, in 1925.

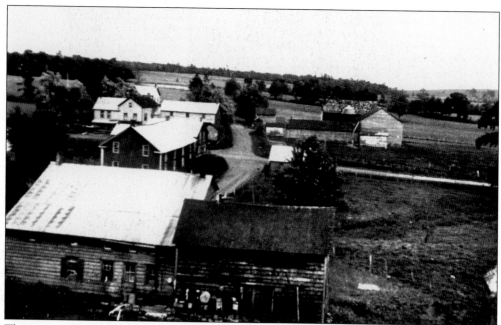

This scene of Rynex Corners was photographed in 1920 from a knoll west of Gregg's barn. The old cheese factory is at the left center; the store and post office, and tavern are on the Old Mariaville Road in the background. The barns in the right background are where the Plotterkill Firehouse now stands.

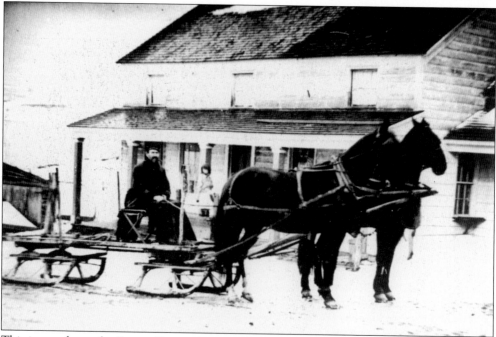

This image shows the Rynex Corners Inn in 1880. It was once the Rynex Hotel and later was run by James Gregg. The town line of Princetown and Rotterdam ran right through the center of the hotel. Princetown was a dry town, and Rotterdam was not; so, when inspectors came to visit, liquor was moved from one side to the other.

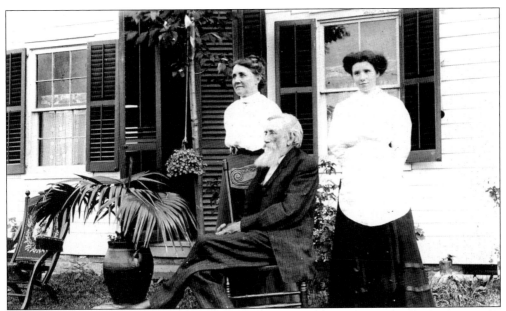

Several Rynex families settled near the Rotterdam town line, and the settlement came to be known as Rynex Corners. James A. Rynex, shown here with his wife Isabella (left) and daughter Elva, was a justice of the peace in the town of Princetown for several years. He had attended the old Princetown Academy, and was a schoolteacher in the town and in Indiana. He was also a carpenter who built several houses in Schenectady.

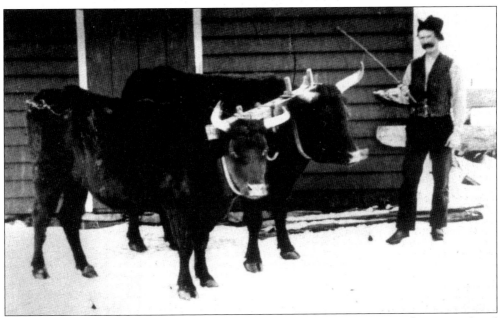

Delmet Gregg poses with his prize oxen at Rynex Corners in 1880. Some farmers preferred working with these powerful but gentle oxen instead of horses. The oxen were less expensive than horses but harder to train.

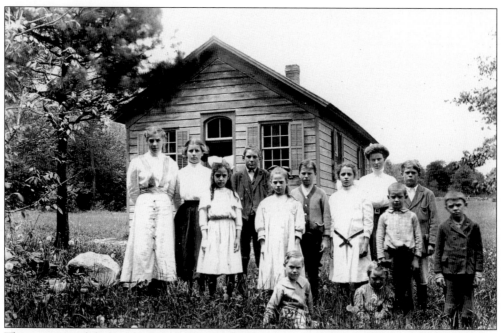

This group stands before the District No. 4 School on Houghton Road. The teacher here is Carrie Aucompaugh, and Elizabeth Ennis is one of her pupils. The other students are not identified.

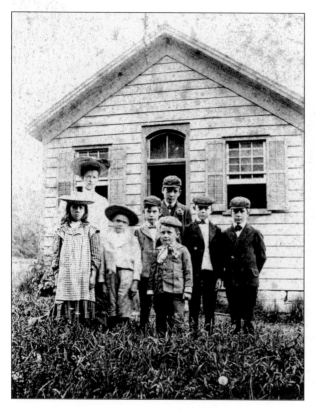

This is another view of District No. 4 School. The pupils are attired in their best clothes and hats, prepared to have their picture taken on this special day.

Eight
PRINCETOWN NORTH

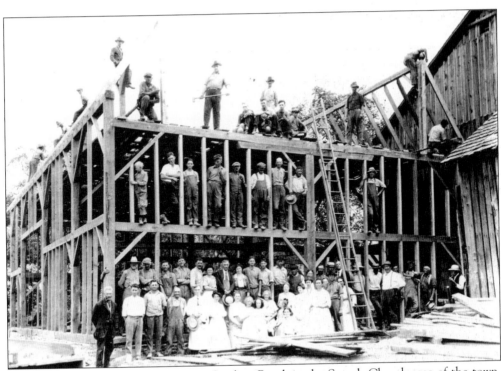

This barn raising for Will Tinning on Sterling Road, in the Scotch Church area of the town, probably took place around 1922. Will Tinning is the tall man in the second story, standing to the left of the ladder. Joseph Tinning, his son, is the boy at far left in the second story. When a farmer needed a barn built, all the neighbors gathered to help raise the bents. There was always plenty of food on hand.

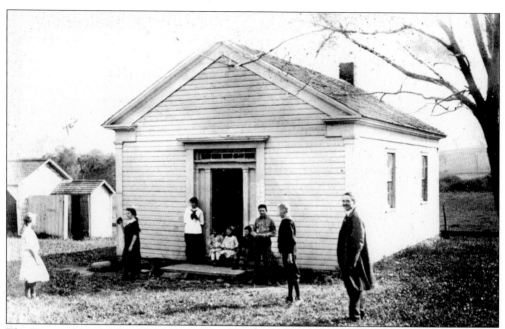

The District No. 5 School was located on the corner of Sterling Road and Route 160. Built in the early 1800s, it was attended by the Scotch families who settled in this area. Since the settlers were associated with the Florida United Presbyterian Church, the area became known as the Scotch Church area. James Wingate is at the right in this picture.

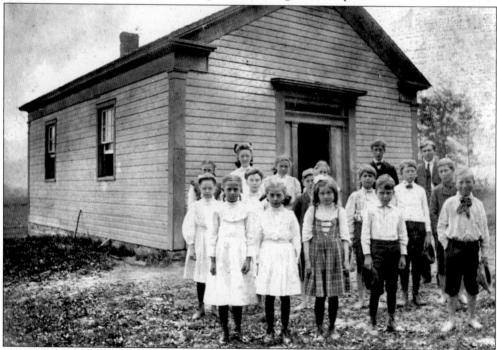

The District No. 5 School was also called the Sanson School, named after the Sanson families that resided in the area. The teacher was Ray Jamison. In 1950, the school was purchased by the Scotch Church Grange to be used as its headquarters.

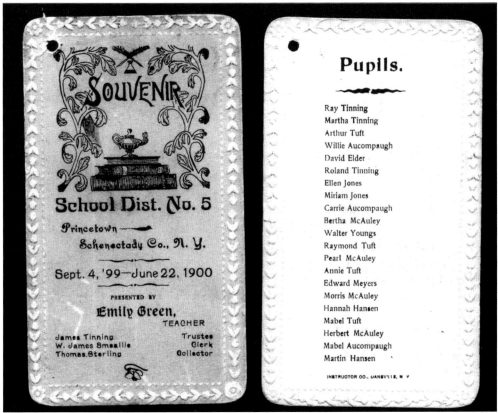

Pupils.

Ray Tinning
Martha Tinning
Arthur Tuft
Willie Aucompaugh
David Elder
Roland Tinning
Ellen Jones
Miriam Jones
Carrie Aucompaugh
Bertha McAuley
Walter Youngs
Raymond Tuft
Pearl McAuley
Annie Tuft
Edward Meyers
Morris McAuley
Hannah Hansen
Mabel Tuft
Herbert McAuley
Mabel Aucompaugh
Martin Hansen

This is a "Souvenir" from the District No. 5 School, located at the corner of Sterling Road and Route 160. Carrie Aucompaugh is listed among the students here. She later became a teacher in the Princetown schools.

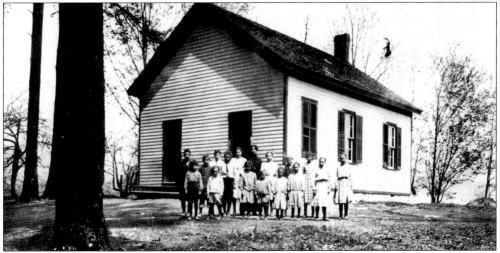

The District No. 6 School was on Florida Road, near the Rotterdam town line. It was known as the Pine Grove School. The schoolhouse was rebuilt in 1927 and is now the home of the Phillips family. This photograph was taken on Arbor Day in 1907. Helen Jeffers is one of the students pictured; the other pupils are unidentified.

The Scheuer Farm was located in the Scotch Church area of Princetown. This picture shows farmers bringing in a load of hay from the fields in 1914. The Scheuers' ancestors were from Germany. They immigrated to this country in the late 1800s.

This Tinning home was on Sterling Road. The Tinnings were from Scotland, and they settled in the Scotch Church area of the town in the mid-1800s. Descendants of these early Tinnings lived in this house and in other surrounding areas.

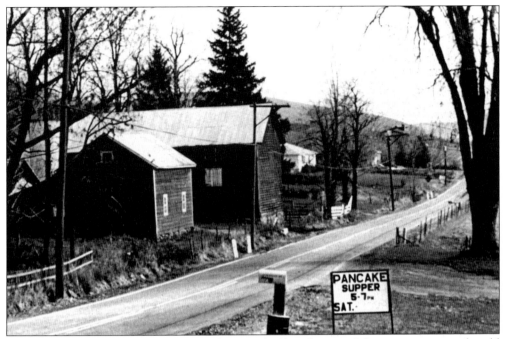

These barns, located on Route 160 in the Scotch Church area of the town, were on the old Leackfeldt Farm. The Scotch Church Grange hall is directly across the road, out of view on the right. The sign is advertising a pancake supper at the Grange.

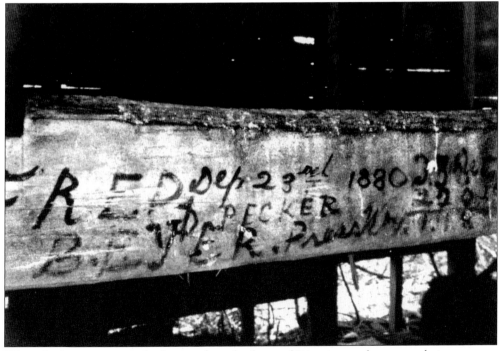

When the hay pressers made the rounds to the farms of Princetown, they wrote their names on the old barn beams. A mixture of kerosene and soot was used for the ink and many names are still visible today.

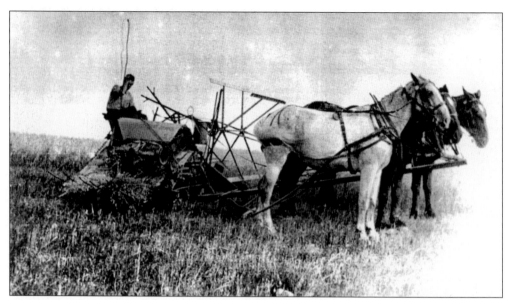

Almost every Princetown farmer owned a reaper and binder. It was an important piece of equipment that was used to cut the farmer's grain of oats, buckwheat, and wheat. The reaper was patented by Cyrus McCormick in 1834.

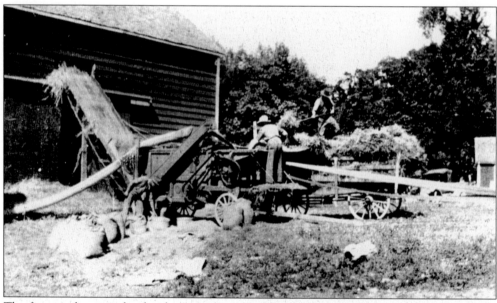

The farmer who owned a threshing machine would make the rounds in late August to thresh the grain at other farms. The grain was used to feed the animals, and the chaff was used for the animal's bedding. It was a dusty, dirty job, and the only compensation was the huge dinner prepared by the wife of the farm owner. All the neighbors helped with the job.

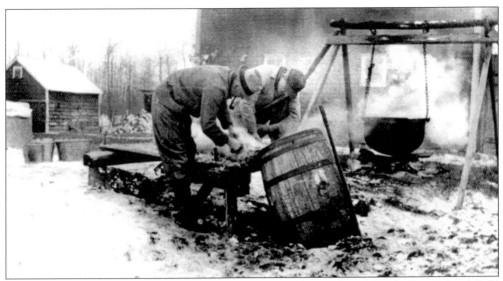

Hog killing occurred when the weather turned cold, usually in early December. Cold temperatures were needed so that the meat would not spoil. Most all Princetown farmers raised hogs for their own use. The hogs supplied the farmers with hams, pork, bacon, sausage, headcheese, and lard. The lard was used for baking. Hams were hung in the smokehouse; other meat was put in crocks down in the cellar or canned by the housewife.

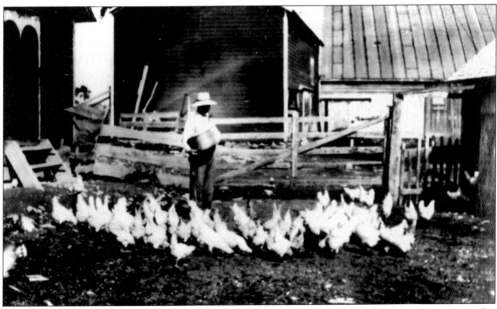

A Mr. Leackfeldt feeds the chickens on his farm in the Scotch Church area of the town. On family farms chickens were allowed to run loose. Once a day they were fed ground feed called mash, and also whole-grain feed called scratch was scattered for the birds each day.

Ruth Bissell taught in several of Princetown's one-room schools. Ruth was born in the Dakota Territory. At the age of 19, she was teaching school in Iowa, riding horseback to and from school. She came to New York State, where she met and married Robert Bradshaw. They lived on the old Bradshaw Farm on Mariaville Road.

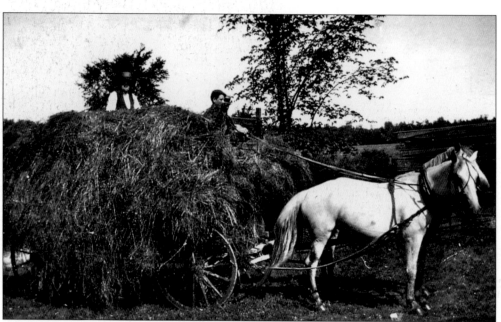

These farmers are bringing in hay from the fields. Loose hay was loaded on wagons and brought into the barn. In the winter, many farmers boarded animals from the Erie Canal in order to earn some extra money.